PALETTE
PERFECT

VOL. 2

Lauren Wager Author of the blog *Color Collective*

PALETTE PERFECT

VOL. 2

Color Combinations by Season.
Inspired by Fashion, Art and Style

HOAKI

Hoaki Books, S.L.
C/ Ausiàs March, 128
08013 Barcelona, Spain
T. 0034 935 952 283
F. 0034 932 654 883
info@hoaki.com
www.hoaki.com

hoaki_books

Palette Perfect, vol. 2
Color Combinations by Season.
Inspired by Fashion, Art and Style

ISBN: 978-84-17656-72-0

Copyright © 2021 Hoaki Books, S.L.

Content editor and texts: Lauren Wager
Foreword text and images: Sophia Naureen Ahmad
Proofreading: Spencer Nelson
Graphic design and layout: Lauren Wager
Layout of the foreword: Claudia Martínez Alonso
Color revision: Paulina Vizán (Ars Satèl·lit)
Project coordination: Anna Tetas
Cover image: Luisa Brimble

Every effort has been made to ensure the credits accurately
match the information supplied. In the event of any
omissions or errors, the publisher would be pleased to make
the appropriate correction for future editions of the book.

D.L.: B 14254-2021
Printed in Turkey

FOREWORD

What color is summer? Is it a cool and translucent swimming pool aqua, dazzling red like watermelon flesh, or the pale pink interior of a seashell? If these colors bring summer to mind, what colors might conjure up autumn? How about winter and spring?

In *Palette Perfect volume 2*, Lauren Wager explores the question of seasonal color, leading the reader through a serene presentation of image pairings and color combinations. This book documents thoughtful color application within the worlds of contemporary art, fashion, interiors, photography, and graphic design. With a touch of the unexpected, it is a carefully gathered collection of color that feels more intuitive than prescriptive. As always, Wager's curation evokes emotion while retaining a quiet elegance. *Palette Perfect volume 2* demonstrates the value of observation and how the practice of seeking beauty can lead to fruitful creation.

In her first book, *Palette Perfect*, Wager characterized color by moods, like 'dreamy',

'magical', and 'mysterious'. This concept originated from her blog, *Color Collective*, which has resonated with over twenty thousand followers. A graphic designer by trade, Wager is known for her ability to express moods through small edits of images and corresponding color palettes.

Color is one essential, yet often overlooked, step in the process of seeing. For anyone with a creative profession or practice—be they designers, artists, photographers, filmmakers, florists, or chefs—the observation of color provides a way to see the world anew, to view it with innocent eyes. Viewing color through the lens of seasonality

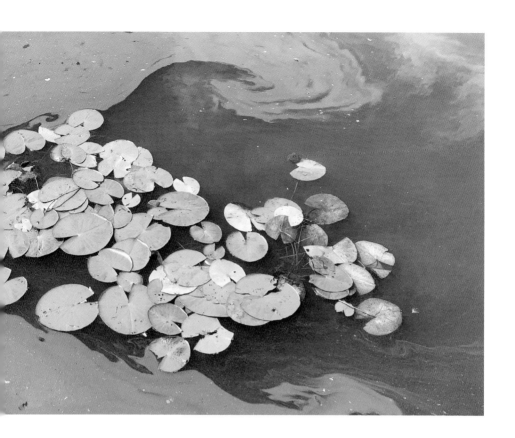

gives us an opportunity to look at color with intention.

Color is a passion for me, both personally and professionally. I work as a colorist, designer, and trend forecaster in the fashion industry. For many years, I have helped brands communicate through color, be it through trend research and forecasting, color naming, developing color palettes, or designing colorways for products. One personal extension of my work is photography. I create images, documenting color stories found in my environment. Though I now work with color for various industries, my point of view remains rooted in fashion.

I came across *Color Collective* at a point in my career when I was voraciously seeking resources on color. One aspect of Wager's work that stood out to me was the way she incorporates fashion imagery. What always attracts me to fashion, and its images in particular, is its agility, the immediacy with which it responds to the cultural moment. Fashion is one way that we communicate about the present—what we consider beautiful, what we deem worthy of our attention—all of which makes it a powerful mode of expression.

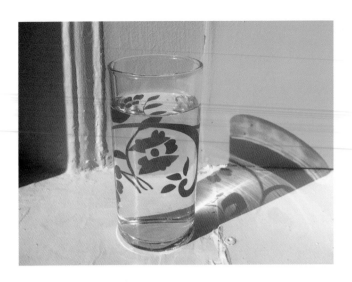

COLOR AND SEASONALITY IN FASHION

Novelty is the currency of fashion. While nothing we see in fashion can be entirely new, it can certainly look and feel that way. Like seasons, fashion is cyclical. Led by a small percentage of early adopters, creators, and tastemakers, fashion collectively senses when it's time to reintroduce an element of the past, to make it feel new again. The game of fashion is figuring out when that moment is. As a creative industry, fashion holds its forward-moving momentum through its plasticity, its willingness to act on intuition, and an awareness of its own rhythms.

One of the key ways fashion transmits newness is through color. A well-known maxim among marketers is that color, if applied at the right time and place, will influence a customer to purchase a product. For that reason, color and fashion experts are frequently asked to comment on the 'color of the season'. The reality is, however, that color trends can take years to enter the collective consciousness and become commercially viable. Rather than radically changing each season or even each year, color trends tend to evolve slowly over time, shifting subtly in new directions.

Traditionally, the fashion industry operates in a binary system of spring/summer and autumn/winter. Creative teams, including designers, trend forecasters, and color/concept specialists, develop new directions for each collection, typically one to two years in advance of reaching the market. Color, with its emotive and expressive powers, plays an essential role in shaping each season's concept. Though there are many elements to consider in creating a collection—key themes and messaging, silhouettes, construction, fabrics, materials, patterns, graphics—color is often one of the early, formative steps in setting a mood and direction for the fashion season.

In fashion, one of the world's most polluting industries, the move toward trans-seasonal or seasonless color is becoming ever more relevant. The threat of climate change is a major shift that can no longer be ignored. With more extreme weather conditions on the rise, seasons as we know them may disappear altogether. Customers aim to consume less overall, and when they do shop, to make more environmentally-conscious choices. Fashion brands are shifting their priorities, now tasked with reducing harm and waste in their dyeing and manufacturing processes. They also have the creative challenge of designing color with adaptable, long-term appeal, lasting from season to season, year to year.

Though it is not absolute, the fashion industry still follows a traditional rhythm regarding what colors work for each season. Pastels are associated with spring, while neons and brights are strongly tied to summer. Autumn and winter are defined by deeper shades, with winter favoring flashy colors for the holidays. This seasonal color code is based on a combination of conventional wisdom, sociocultural norms, and seasonal sales patterns. Adherence to the code will vary depending on new trends, product categories, and geographical markets.

The seasonal color code may seem too limiting for an industry as mercurial as fashion, but it does serve a purpose. Our culture, traditions, memories, and sensorial associations are all factors that influence our color-related decisions. Choosing what colors to wear, whether consciously or not, is one way that we connect emotionally to a given period of time. Therefore, we can generally anticipate what colors customers will want to wear at specific times of the year. In preparation for summer, one might instinctively search for a swimsuit in bright lime or fuchsia. Come autumn, one might instead be inclined toward more subdued shades, like a scarf in deep cranberry.

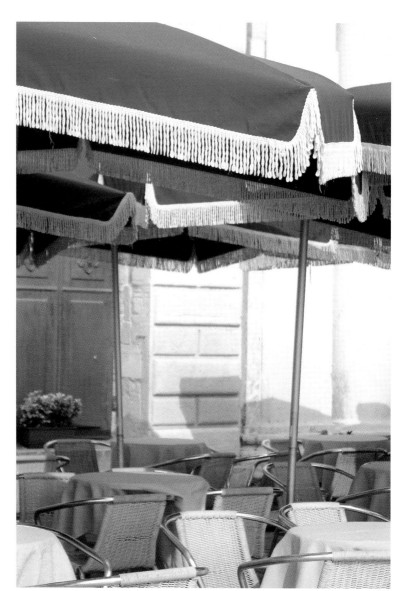

Each season, fashion brands work hard to tell customers a color story that is both familiar enough to be understood and new enough to feel exciting. One of the challenges of working with color in fashion lies in how to make traditional color feel new. Brands strategically craft and implement color so that, in a given year, each season's color story looks distinct both from its counterparts and from last year's corresponding color story. Meaning, for example, that autumn must be distinguishable from winter, spring, and summer, while also appearing to have evolved from last autumn.

So how do colorists discern one autumn's cranberry from another? While undetectable to the inexperienced eye, color professionals can observe subtle differences in brightness, intensity and temperature. The ability to identify such nuances allows for recognition of what colors feel the most modern, naturally evolving from the colors customers have grown used to seeing, wearing, and living with.

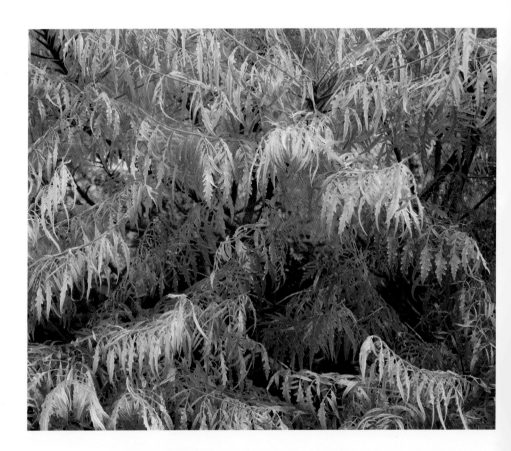

DEFINING COLOR

Words help shape the story behind a color concept or palette. Whether addressing an external client or internal creative team, language is crucial to 'selling' a color story to an audience. What makes a particular color compelling, and why now? What does this color refer to visually? How might this color feel, sound, smell, or taste? Verbal language contextualizes an esoteric subject like color, allowing audiences to connect with it on an emotional level.

The terms hue, tint, tone, and shade have their own distinct meanings, but are often used interchangeably, even in professional design circles. Color terminology, when employed correctly, helps us distinguish one color from another. It also enables us to communicate practical information about color each season. In fashion, it is rare to see color applied perfectly to a material on the first try. Using the right language minimizes errors and delays in the manufacturing process, ensuring that a product's design is executed as intended. The better

we can communicate about color, the better we can evoke emotion through color.

Because seasons are defined by light and temperature, they can help us better understand some of the basics of color theory. Seasonality is employed in the examples under each key term below.

Hue

Hue refers to the colors of the visible light spectrum that we associate with basic color names: red, orange, yellow, green, blue, and violet.

Example: *While daffodil and maple may be striking in their differences, both colors share a hue: yellow.*

Value

Value refers to a color's degree of lightness or darkness. Colors of higher value are lighter, and colors of lower value are darker.

Example: *Winter offers a range of high and low value in citrus colors, from white grapefruit to blood orange.*

Saturation

Saturation, also known as chroma or intensity, describes the quality of a color's purity. Adding white, grey, or black to a color reduces its purity. Saturation may also describe a color's intensity under various lighting conditions.

Example: *The color of lavender fields appears most saturated in summer, around midday.*

Tint

A tint is a hue mixed with white, reducing its purity and giving it a lighter or brighter appearance.

Example: *On early winter mornings, snow-covered landscapes appear to be tinted blue.*

Tone

A tone is a hue mixed with grey, reducing its purity and giving it a darker, duller appearance.

Example: *After spring storms, rainbows emerge against grey skies, producing soft light in tones of red, orange, yellow, green, blue, indigo, and violet.*

Shade

A shade is a hue mixed with black, reducing its purity and giving it a darker, deeper appearance.

Example: *In autumn, leaves transition from vibrant green to dark shades of red, orange, yellow, and purple.*

Warm and Cool

Color temperature does not refer to any thermal value, but describes a color on a relative scale of warm and cool. Warm colors contain at least some red or yellow (the warmest hues), while cool colors contain at least some blue (the coolest color).

Example: *While both are red-hued summer berries, raspberries appear cooler, or bluer, than strawberries do.*

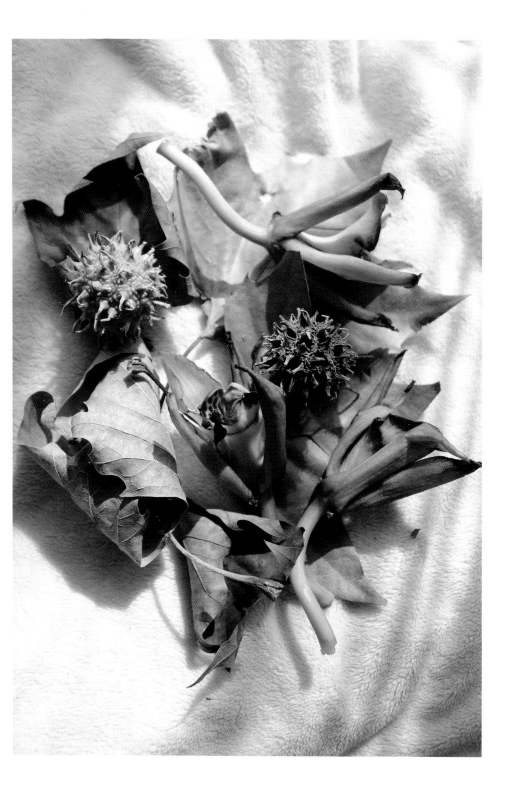

DEFINING SEASONS

In this book, there are four chapters for four seasons. While the concept of four distinct seasons is widely recognized, it is not universally experienced. Seasons exist because Earth rotates on a slightly tilted axis, meaning that different areas of the planet receive varying degrees of sunlight throughout the year. Earth's polar regions receive the least direct sunlight, which is why they remain cold all year round. The tropics, the region closest to the equator, receives the most direct sunlight, resulting in a consistently hot climate.

The notion of the seasonal quartet—summer, autumn, winter, spring—comes

from regions of the planet with more moderate climates. It is incorporated into the Gregorian calendar, which is now the world's predominant dating system. Even in parts of the world where four distinct seasons do not occur, the seasonal quartet may still exist vividly in the cultural imagination.

The Gregorian calendar defines the beginnings of each season astronomically, in terms of where Earth is positioned relative to the Sun. Since ancient times, cultures around the world have recognized these moments as essential points of transition worthy of ceremony and celebration. Below are four key points in Earth's positioning that mark the onset of each season.

Summer Solstice
The arrival of summer takes place when Earth's axis points toward the Sun, and the Sun is positioned over the Tropic of Cancer. It is the longest day of the year, occurring in June for the Northern Hemisphere and in December for the Southern Hemisphere.

Autumnal Equinox
The arrival of autumn takes place when the Sun is positioned over the equator, and Earth's axis is perpendicular to the Sun's rays. The length of day and night are about equal. It occurs in September for the Northern Hemisphere and in March for the Southern Hemisphere.

Winter Solstice

The arrival of winter takes place when Earth's axis points away from the Sun, and the Sun is positioned over the Tropic of Capricorn. It is the shortest day of the year, occurring in December for the Northern Hemisphere and in June for the Southern Hemisphere.

Vernal Equinox

The arrival of spring takes place when the Sun is positioned over the equator, and Earth's axis is perpendicular to the Sun's rays. The length of day and night are about equal. It occurs in March for the Northern Hemisphere and in September for the Southern Hemisphere.

THE EMOTIONAL LIFE OF SEASONS

In this book, summer color is presented in circular swatches, a shape well-suited for the season that embodies life at its fullest—the year's round, robust middle. Autumn color is represented by the square, speaking to the groundedness of this part of the year. The diamond represents winter, a symbol of focus, strength, and inner balance. Finally, the upward-pointing triangle speaks for spring, suggesting hope, growth, and ascension.

Although spring is synonymous with rebirth, each season throughout the year bears a significant shift in mood, rhythm, and atmosphere. This poses the question: what if we could welcome each phase of the year with anticipation of a refreshed perspective? Meaning that, at any given time, we would never be more than a few months away from recharge and renewal. With deeper knowledge of nature's cycle, we might be better equipped to move through each season with intention.

Summer is a rare point in the year in which pleasure becomes a priority. With more hours of daylight, the days seem to stretch infinitely. A season with its own brand of romance: rushed, sensual, fleeting. Wearing lighter, diaphanous layers heightens awareness of the body. Heat leads to cravings for water and fresh fruit. Thankfully, summer produce bursts with flavor: sweet yellow corn, tart cherries, juicy tomatoes, tangy limes, leafy greens. Summer blooms—peonies, marigolds, bougainvillea—are sprawling, joyful, confident.

The golden hour in this season is brief, yet especially potent; right after sunrise and before sunset, the sun emits a soft, warm glow that beautifies everything it touches. At midday, however, the summer sunlight turns harsh, bright enough to be blinding: high-contrast light with pitch-black shadows. The flattening heat and humidity make the thought of movement seem impossible. With all its intensity, summer can be an imposing season.

Autumn brings us back down to earth. We witness the landscape soften and become more impressionistic. While the air chills, lush greens dissolve into a flourish of warm harvest shades: golden wheat, pumpkin, butternut, aubergine. This striking moment of transition is akin to spring's first bloom. Dried leaves and earth give us a bounty of brown—a generous neutral that tends to enhance the appearance of the colors around it.

Though it is a time of abundance and nourishment, autumn is ultimately about acceptance. Leaves drop to the ground, signaling what lies ahead of us. Perhaps this is nature's way of demonstrating the beauty of letting things go, of fading and falling.

Winter is summer's opposite, noted for its absence of light and warmth. It can be a difficult stage in nature's cycle, making us more susceptible to illness and depression. With shorter days and little light, the body attempts to preserve energy by sleeping longer and craving heartier foods. It is a time for deep rest, repair, and restoration. In winter, we harness our strength and resources in preparation for brighter days ahead.

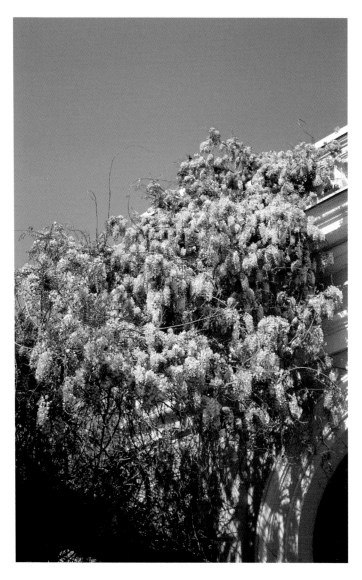

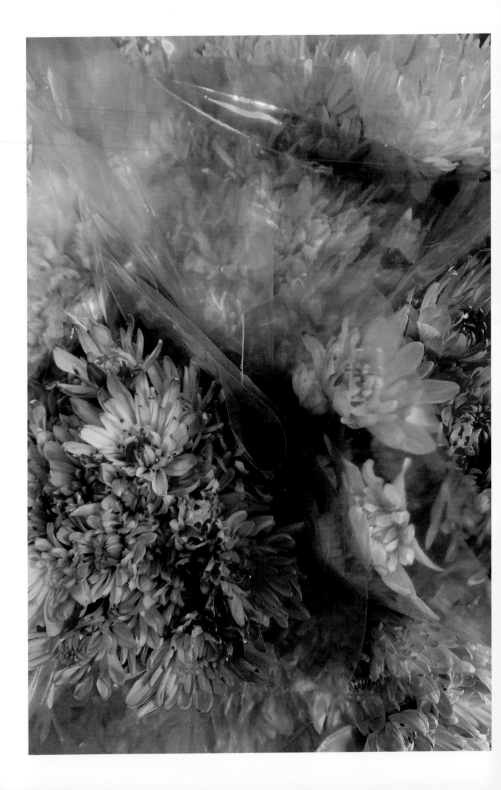

It is also a time of lavish festivity, no doubt a reaction to the gloominess of the season. Winter offers unique glimpses of light, like the delicate gold spotted on bare branches around dawn and dusk. Depending on latitude, nature grants winter a longer golden hour than it does summer. There is also the reflectiveness of all-white snowscapes—brilliant during the daytime and apparent even at night, illuminating the darkness. We find bits of radiant energy in winter's cold, crisp atmosphere: in crackling fires that keep us warm, and in a variety of citrus fruits, rich in vitamins that heal us—oranges, pink lemons, green pomelos, redblush grapefruit.

Spring is a quick wit. It always seems to arrive overnight, almost as a surprise. While it is regarded as a bright spot in the year, spring is, in fact, a heady blend of sunshine and storms. As the air warms up, rain pours down. Temperatures rise and fall, making spring a temperamental season. While this time of year can be exhilarating, it can also cause a unique ailment, making one crazed with newfound energy and romance, or plagued with allergies and fatigue. We call it 'spring fever'.

Despite its fickle nature, spring is a new day, a chance to once again see the world with innocence and optimism. Longer, sunnier days mean more heat and light energy for plants, speeding up the blooming process. It is no coincidence that this season is called spring, meaning 'to jump forth rapidly'. Many colors that we associate with this time of year are named after flowers—periwinkle, cornflower, lilac, primrose, buttercup. They are sweet, gentle, fragrant reminders of the blooming season.

WHAT COLOR AND
SEASONS SHARE

The existence of seasons relies on continuous movement. Color, like seasons, can never be truly static, nor exist in isolation. How we perceive one depends on our experience of its counterparts. We can look to the world of interiors for an example. If one were to paint a bedroom in electric chartreuse, it might overstimulate and fatigue the senses. What if, instead, one placed a lamp of the same color against a navy-blue wall? The dark, muted blue would absorb some of the bright yellow-green's frenetic energy, making it easier to take in, like the relief of an autumn breeze wafting over one's skin after those last simmering days of summer.

Color and seasonality are two elements capable of shaping our experience of a particular time and atmosphere. Both can affect our moods, emotions, appetites, and energy levels. In modern life, we experience so much of life digitally. We spend most of our time indoors under controlled lighting and temperature conditions, making it easy to overlook the subconscious forces influencing our moods and behavior.

Seasons continuously move us forward in time. The passing of each season is inevitable; its beauty lies in its ephemeral nature. Through its own unique expression of color and light, each season carries us toward a new phase of living with new sights, scents, sounds, and sensations. Seasons speak on nature's behalf, pleading with us to be present. Each season, like each color, carries its own inherent wisdom, and with it, an awareness of its own beauty and its own limitations.

Text and images by
Sophia Naureen Ahmad

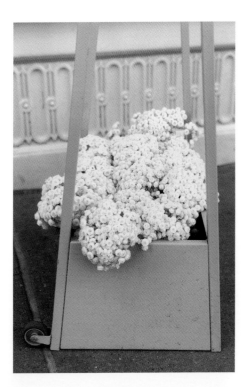

Sophia Naureen Ahmad is a colorist, designer and trend forecaster working in the fashion, footwear and product space.

sophianahmad.com

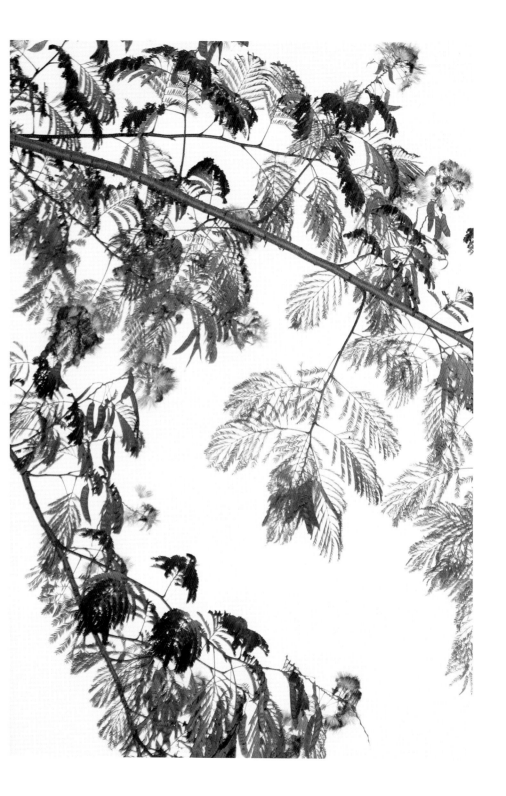

CLASSICS

Summer is a joyful time of year—the days are long and full of sunshine and warmth. Summer is a time for adventures and play. We associate summertime with being outside and there is often a youthful, nostalgic feeling we get from this season. The emotions evoked by summertime are reflected in the colors we see, particularly in nature. Classic summer colors are blue (think blue skies), yellow and orange (sunshine and hazy days), and green (grassy fields). We also see accent colors such as pink (seen in the flowers), and aqua (fresh ocean water).

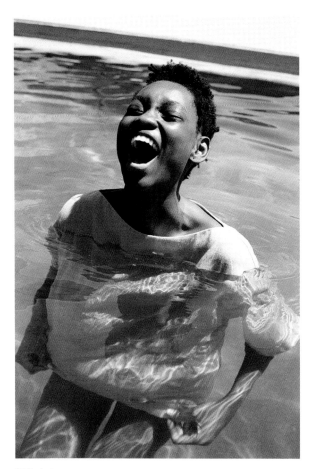

Sophia Aerts

CMYK 38/4/20/0
RGB 156/207/205

CMYK 3/7/69/0
RGB 250/226/110

CMYK 20/6/5/0
RGB 201/220/231

CMYK 3/7/69/0
RGB 250/226/110

CMYK 2/3/2/0
RGB 246/243/243

CMYK 56/16/31/0
RGB 117/176/177

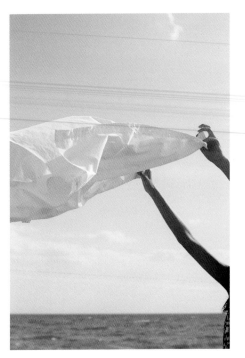

Sophia Aerts

*"**Summertime** is always the **best** of what might be."*

-Charles Bowden

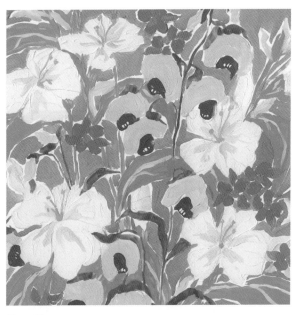

Margaret Jeane

CMYK 55/19/40/0
RGB 123/170/159

CMYK 2/4/7/0
RGB 247/240/232

CMYK 0/8/10/0
RGB 255/235/222

CMYK 0/48/52/0
RGB 254/155/118

CMYK 64/36/0/0
RGB 93/143/206

CMYK 14/32/62/0
RGB 220/174/115

CMYK 2/4/7/0
RGB 247/240/232

CMYK 64/36/0/0
RGB 93/143/206

CMYK 17/9/7/0
RGB 207/216/224

CMYK 33/5/25/0
RGB 172/210/197

CMYK 14/32/62/0
RGB 220/174/115

CMYK 0/6/7/0
RGB 255/238/228

CMYK 20/13/11/0
RGB 202/207/213

CMYK 0/6/7/0
RGB 255/238/228

CMYK 0/48/52/0
RGB 254/155/118

CMYK 0/48/52/0
RGB 254/155/118

CMYK 17/9/7/0
RGB 207/216/224

CMYK 55/19/40/0
RGB 123/170/159

CMYK 0/6/7/0
RGB 255/238/228

CMYK 64/36/0/0
RGB 93/143/206

CMYK 33/5/25/0
RGB 172/210/197

CMYK 20/13/11/0
RGB 202/207/213

CMYK 0/6/7/0
RGB 255/238/228

CMYK 14/32/62/0
RGB 220/174/115

CMYK 67/28/45/3
RGB 91/146/140

CMYK 0/6/7/0
RGB 255/238/228

CMYK 0/19/24/0
RGB 254/212/187

29

CMYK 32/4/4/0
RGB 169/213/234

CMYK 25/15/90/0
RGB 198/192/68

CMYK 14/0/11/0
RGB 217/238/229

CMYK 0/5/6/0
RGB 252/240/233

CMYK 2/17/23/0
RGB 246/213/191

CMYK 24/0/63/0
RGB 200/227/130

CMYK 0/19/16/0
RGB 253/213/201

CMYK 9/8/33/0
RGB 233/223/179

CMYK 46/8/73/0
RGB 149/190/111

CMYK 63/35/61/12
RGB 99/128/107

CMYK 42/15/78/0
RGB 159/181/99

CMYK 1/4/33/0
RGB 253/238/183

CMYK 22/14/74/0
RGB 206/198/103

CMYK 32/4/4/0
RGB 169/213/234

CMYK 14/2/55/0
RGB 223/227/143

CMYK 14/2/55/0
RGB 223/227/143

CMYK 29/19/100/0
RGB 192/184/97

CMYK 56/17/59/1
RGB 124/170/131

CMYK 32/36/97/7
RGB 161/143/53

CMYK 0/4/4/0
RGB 253/244/239

CMYK 0/19/16/0
RGB 253/213/201

CMYK 0/5/6/0
RGB 252/240/233

CMYK 32/4/4/0
RGB 169/213/234

CMYK 14/0/11/0
RGB 217/238/229

CMYK 0/28/35/0
RGB 253/194/160

CMYK 63/35/61/12
RGB 99/128/107

CMYK 0/5/6/0
RGB 252/240/233

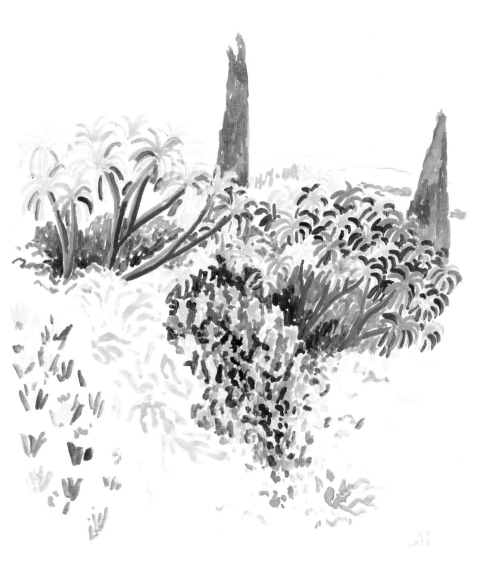

Rosie Harbottle

CMYK 21/3/4/0
RGB 198/225/236

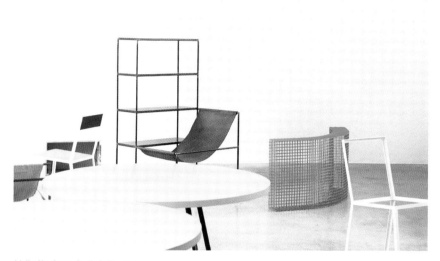

Muller Van Severen Studio © Fien Muller

CMYK 0/16/19/0
RGB 253/218/198

CMYK 27/0/14/0
RGB 175/253/237

CMYK 18/69/78/5
RGB 197/104/170

CMYK 67/15/55/1
RGB 88/165/137

CMYK 21/3/4/0
RGB 198/225/236

CMYK 27/0/14/0
RGB 175/253/237

CMYK 21/3/4/0
RGB 198/225/236

CMYK 67/15/55/1
RGB 88/165/137

CMYK 0/16/19/0
RGB 253/218/198

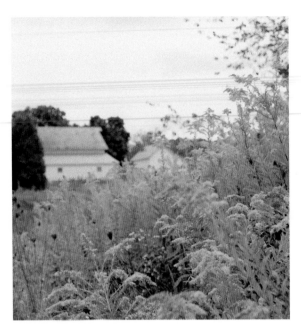

Cassidie Rahall

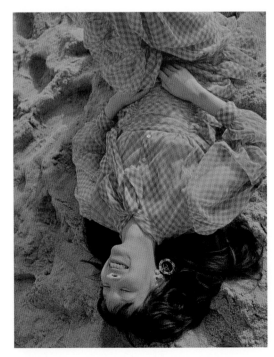

Arianna Lago

CMYK 0/25/12/0
RGB 250/202/201

CMYK 1/2/4/0
RGB 249/246/240

CMYK 11/26/78/0
RGB 228/186/86

CMYK 19/52/100/3
RGB 202/132/36

CMYK 18/14/65/4
RGB 204/193/114

CMYK 4/6/67/0
RGB 248/228/116

CMYK 2/7/13/0
RGB 249/234/219

CMYK 4/6/67/0
RGB 248/228/116

CMYK 0/40/48/0
RGB 253/170/130

CMYK 17/14/11/0
RGB 208/208/213

CMYK 2/7/13/0
RGB 249/234/219

CMYK 18/14/65/4
RGB 204/193/114

CMYK 0/40/48/0
RGB 253/170/130

CMYK 19/52/100/3
RGB 202/132/36

CMYK 2/7/13/0
RGB 249/234/219

CMYK 5/14/61/0
RGB 243/213/145

CMYK 1/2/4/0
RGB 249/246/240

CMYK 0/40/48/0
RGB 253/170/130

CMYK 0/25/12/0
RGB 255/203/202

CMYK 1/2/4/0
RGB 249/246/240

CMYK 0/25/12/0
RGB 255/203/202

CMYK 11/26/78/0
RGB 228/186/86

CMYK 19/52/100/3
RGB 202/132/36

CMYK 18/14/65/4
RGB 204/193/114

CMYK 2/7/13/0
RGB 249/234/219

CMYK 4/6/67/0
RGB 248/228/116

CMYK 11/26/78/0
RGB 228/186/86

CMYK 2/2/7/0
RGB 247/244/235

CMYK 24/4/37/0
RGB 195/216/175

CMYK 23/1/27/0
RGB 197/225/197

CMYK 76/24/65/6
RGB 65/143/114

CMYK 45/5/53/0
RGB 146/196/147

CMYK 5/3/94/0
RGB 249/230/40

CMYK 5/3/94/0
RGB 249/230/40

CMYK 23/1/27/0
RGB 197/225/197

CMYK 29/2/92/0
RGB 193/211/65

CMYK 2/2/7/0
RGB 247/244/235

CMYK 24/4/37/0
RGB 195/216/175

CMYK 72/10/100/1
RGB 82/168/61

CMYK 7/11/24/0
RGB 235/220/194

CMYK 4/2/74/0
RGB 250/235/100

CMYK 2/3/3/0
RGB 248/243/240

CMYK 76/24/65/6
RGB 65/143/114

CMYK 58/11/66/0
RGB 119/178/124

CMYK 29/2/92/0
RGB 193/211/65

CMYK 2/3/3/0
RGB 249/118/95

CMYK 23/1/27/0
RGB 197/225/197

CMYK 18/22/31/0
RGB 210/192/172

CMYK 2/3/3/0
RGB 248/243/240

CMYK 5/3/94/0
RGB 249/230/40

CMYK 4/6/70/0
RGB 249/227/208

CMYK 76/24/65/6
RGB 65/143/114

CMYK 7/11/24/0
RGB 235/220/194

CMYK 29/2/92/0
RGB 193/211/65

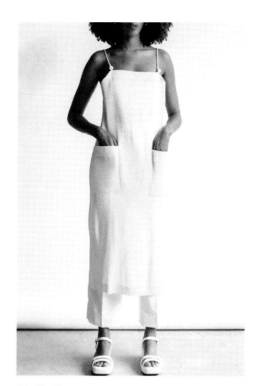

I Am That Shop

Liana Jegers

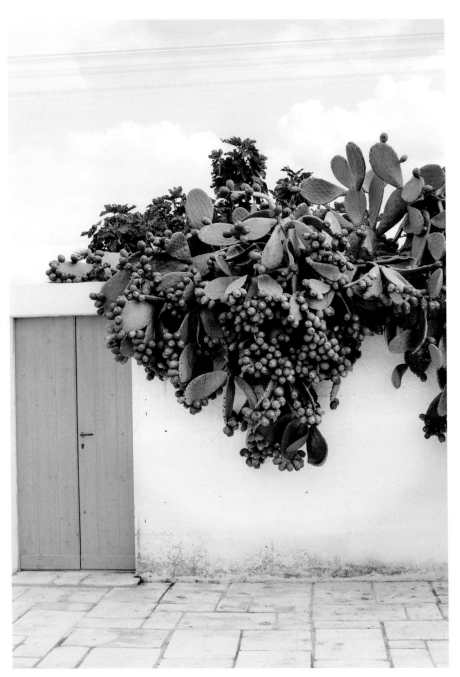

Hanna Sihvonen (xo amys)

CMYK 16/8/8/0
RGB 210/220/225

CMYK 0/64/88/0
RGB 255/125/50

CMYK 45/17/62/0
RGB 150/177/125

CMYK 2/2/8/0
RGB 246/243/231

CMYK 57/6/54/0
RGB 113/185/145

CMYK 10/3/1/0
RGB 226/236/246

CMYK 9/7/12/0
RGB 231/228/219

CMYK 45/17/62/0
RGB 150/177/125

CMYK 10/3/1/0
RGB 226/236/246

CMYK 0/69/98/0
RGB 254/112/30

CMYK 74/52/62/38
RGB 59/80/75

CMYK 63/42/45/10
RGB 103/118/125

CMYK 32/72/79/25
RGB 144/79/57

CMYK 9/7/12/0
RGB 231/228/219

CMYK 57/6/54/0
RGB 113/185/145

CMYK 57/6/54/0
RGB 113/185/145

CMYK 0/69/98/0
RGB 254/112/30

CMYK 9/7/12/0
RGB 231/228/219

CMYK 10/3/1/0
RGB 226/236/246

CMYK 16/8/8/0
RGB 210/220/225

CMYK 0/69/98/0
RGB 254/112/30

CMYK 2/2/8/0
RGB 246/243/231

CMYK 57/6/54/0
RGB 113/185/145

CMYK 45/17/62/0
RGB 150/177/125

CMYK 74/52/62/38
RGB 59/80/75

CMYK 5/7/15/0
RGB 240/231/215

CMYK 78/49/67/43
RGB 46/76/66

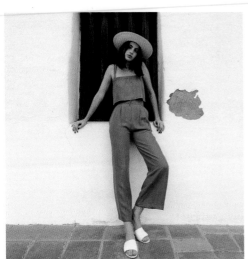

Danica Ferrin Klein for First Rite SS16 / Photo: María del Río *Made by Jens*

CMYK 65/42/9/0
RGB 93/48/193

CMYK 2/2/8/0
RGB 246/243/231

CMYK 5/52/78/0
RGB 235/143/78

CMYK 5/52/78/0
RGB 235/143/78

CMYK 29/51/50/3
RGB 180/130/118

CMYK 2/2/8/0
RGB 246/243/231

CMYK 2/2/8/0
RGB 246/243/231

CMYK 65/42/9/0
RGB 93/48/193

CMYK 22/33/31/0
RGB 199/170/162

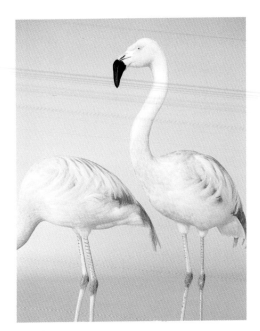

Sophia Aerts

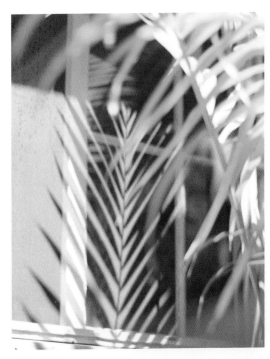

Marissa Rodriguez

CMYK 2/23/7/0
RGB 245/203/210

CMYK 2/4/7/0
RGB 247/240/232

CMYK 11/37/63/0
RGB 225/166/110

CMYK 1/15/5/0
RGB 247/220/224

CMYK 2/4/7/0
RGB 247/240/232

CMYK 21/0/64/0
RGB 208/238/126

CMYK 2/4/7/0
RGB 247/240/232

CMYK 31/18/77/0
RGB 185/185/96

CMYK 67/15/100/2
RGB 97/161/49

CMYK 1/15/5/0
RGB 247/220/224

CMYK 2/4/7/0
RGB 247/240/232

CMYK 11/37/63/0
RGB 225/166/110

CMYK 66/12/100/1
RGB 101/167/35

CMYK 11/18/66/0
RGB 229/200/114

CMYK 2/23/7/0
RGB 245/203/210

CMYK 11/37/63/0
RGB 225/166/110

CMYK 11/18/66/0
RGB 229/200/114

CMYK 2/23/7/0
RGB 254/236/238

CMYK 0/8/2/0
RGB 249/118/95

CMYK 0/8/2/0
RGB 249/118/95

CMYK 2/23/7/0
RGB 245/203/210

CMYK 21/0/64/0
RGB 208/238/126

CMYK 11/37/63/0
RGB 225/166/110

CMYK 2/23/7/0
RGB 245/203/210

CMYK 66/12/100/1
RGB 101/167/35

CMYK 2/4/7/0
RGB 247/240/232

CMYK 11/18/66/0
RGB 229/200/114

CMYK 7/5/5/0
RGB 235/235/235

CMYK 33/11/11/0
RGB 168/201/214

CMYK 16/42/71/1
RGB 213/154/96

CMYK 55/27/0/0
RGB 115/163/215

CMYK 0/65/61/0
RGB 251/123/96

CMYK 33/8/21/0
RGB 171/205/200

CMYK 3/16/24/0
RGB 244/214/189

CMYK 12/5/42/0
RGB 227/225/167

CMYK 55/27/0/0
RGB 115/163/215

CMYK 7/5/5/0
RGB 235/235/235

CMYK 4/24/26/0
RGB 240/198/178

CMYK 21/11/4/0
RGB 198/210/227

CMYK 16/42/71/1
RGB 213/154/96

CMYK 0/65/61/0
RGB 251/123/96

CMYK 7/5/5/0
RGB 235/235/235

CMYK 33/11/11/0
RGB 168/201/214

CMYK 33/8/21/0
RGB 171/205/200

CMYK 4/8/9/0
RGB 241/231/225

CMYK 55/27/0/0
RGB 115/163/215

CMYK 7/5/5/0
RGB 235/235/235

CMYK 4/24/26/0
RGB 240/198/178

CMYK 7/5/5/0
RGB 235/235/235

CMYK 16/42/71/1
RGB 213/154/96

CMYK 33/11/11/0
RGB 168/201/214

CMYK 0/65/61/0
RGB 251/123/96

CMYK 12/5/42/0
RGB 227/225/167

CMYK 1/49/83/0
RGB 245/150/67

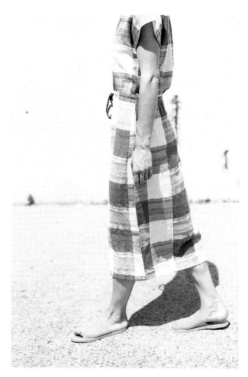

Oroboro Store

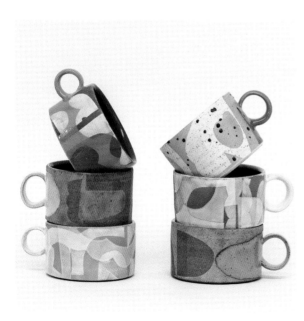

Saltstone Ceramics

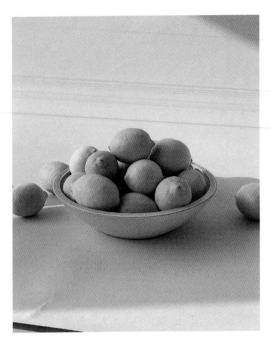

Bombabird Ceramics

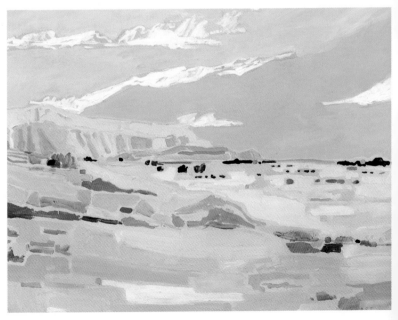

Margaret Jeane

CMYK 24/3/11/0
RGB 191/222/224

CMYK 54/20/49/1
RGB 125/167/143

CMYK 4/22/70/0
RGB 243/198/103

CMYK 4/7/24/0
RGB 243/230/198

CMYK 0/29/17/0
RGB 251/193/188

CMYK 28/17/83/0
RGB 193/188/82

CMYK 0/33/64/0
RGB 254/182/108

CMYK 4/7/24/0
RGB 243/230/198

CMYK 2/22/14/0
RGB 245/204/200

CMYK 13/3/27/0
RGB 222/229/195

CMYK 33/26/100/1
RGB 182/168/1

CMYK 0/38/15/0
RGB 255/178/183

CMYK 4/7/24/0
RGB 243/230/198

CMYK 25/3/5/0
RGB 187/221/233

CMYK 58/29/61/6
RGB 115/145/115

CMYK 0/29/17/0
RGB 251/193/188

CMYK 54/20/49/1
RGB 125/167/143

CMYK 3/4/41/0
RGB 250/136/168

CMYK 2/28/56/0
RGB 248/190/125

CMYK 4/7/24/0
RGB 243/230/198

CMYK 44/29/100/5
RGB 152/152/40

CMYK 24/3/11/0
RGB 191/222/224

CMYK 68/40/78/28
RGB 79/103/69

CMYK 4/22/70/0
RGB 243/198/103

CMYK 20/33/91/1
RGB 207/165/61

CMYK 4/7/24/0
RGB 243/230/198

CMYK 35/8/14/0
RGB 164/204/212

NEUTRALS

Summer can also be associated with slowing things down, and taking a break from the busy world around us. We generally take summertime to indulge in vacations, travel, and to connect with nature. Summer neutrals are light, gentle and subtle. Tans, beiges, and light pinks mirror the sandy beaches, soft yellows imitate the light of the morning sunshine, and muted blues and greens transform us to the ponds and meadows in the countryside.

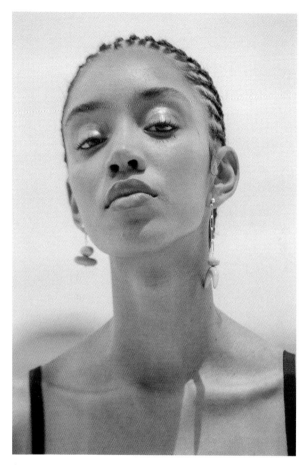

G.Binsky / Photo: Leco Moura

CMYK 14/5/17/7
RGB 203/211/198

CMYK 1/4/4/0
RGB 250/242/238

CMYK 16/33/41/0
RGB 213/173/147

CMYK 33/34/64/3
RGB 174/155/110

CMYK 18/8/11/0
RGB 208/218/218

CMYK 0/10/8/2
RGB 247/225/219

CMYK 7/17/19/0
RGB 233/210/197

CMYK 4/4/6/0
RGB 241/238/234

CMYK 47/48/30/6
RGB 140/125/132

CMYK 27/32/48/0
RGB 189/165/136

CMYK 12/7/12/0
RGB 222/226/220

CMYK 5/10/2/4
RGB 227/217/225

CMYK 14/15/17/7
RGB 203/211/198

CMYK 2/2/7/0
RGB 247/244/235

CMYK 27/32/48/0
RGB 189/165/136

CMYK 2/2/7/0
RGB 247/244/235

CMYK 5/10/2/4
RGB 227/217/225

CMYK 0/10/8/2
RGB 247/225/219

CMYK 12/7/12/0
RGB 222/226/220

CMYK 37/29/31/0
RGB 165/175/169

CMYK 2/2/7/0
RGB 247/244/235

CMYK 2/2/7/0
RGB 247/244/235

CMYK 9/9/13/0
RGB 230/223/214

CMYK 12/7/12/0
RGB 222/226/220

CMYK 43/32/45/2/0
RGB 151/155/140

CMYK 14/15/17/7
RGB 203/211/198

CMYK 2/2/7/0
RGB 247/244/235

CMYK 7/17/19/0
RGB 233/210/197

CMYK 27/32/48/0
RGB 189/165/136

CMYK 43/32/45/2/0
RGB 151/155/140

CMYK 27/32/48/0
RGB 189/165/136

CMYK 1/4/4/0
RGB 250/242/238

CMYK 7/17/19/0
RGB 233/210/197

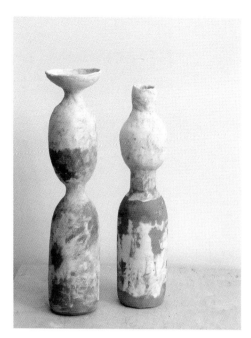

Yuko Nishikawa

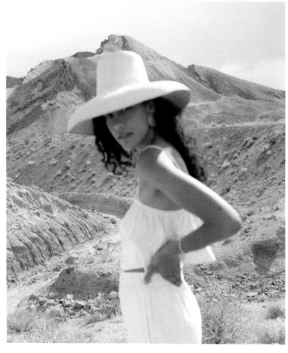

Arianna Lago

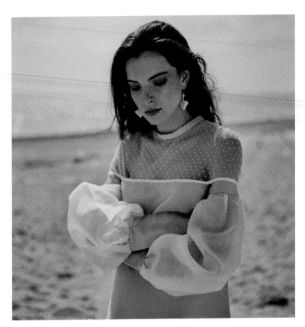

The Vamoose / Photo: Benjamin Wheeler

Anastasi Holubchyk by Moreartsdesign

CMYK 1/15/20/0
RGB 250/219/198

CMYK 16/33/54/0
RGB 213/170/127

CMYK 1/3/12/0
RGB 252/243/224

CMYK 10/21/17/0
RGB 226/200/196

CMYK 12/27/23/0
RGB 222/188/181

CMYK 3/14/19/0
RGB 244/218/200

CMYK 10/21/17/0
RGB 226/200/196

CMYK 10/35/43/0
RGB 227/173/142

CMYK 1/3/12/0
RGB 252/243/224

CMYK 3/14/19/0
RGB 244/218/200

CMYK 12/27/23/0
RGB 222/188/181

CMYK 16/33/54/0
RGB 213/170/127

CMYK 16/33/54/0
RGB 213/170/127

CMYK 9/7/8/0
RGB 229/228/226

CMYK 1/3/12/0
RGB 252/243/224

CMYK 1/15/20/0
RGB 250/219/198

CMYK 1/3/12/0
RGB 252/243/224

CMYK 16/33/54/0
RGB 213/170/127

CMYK 15/11/15/0
RGB 214/213/208

CMYK 1/3/12/0
RGB 252/243/224

CMYK 12/27/23/0
RGB 222/188/181

CMYK 3/14/19/0
RGB 244/218/200

CMYK 16/33/54/0
RGB 213/170/127

CMYK 9/7/8/0
RGB 229/228/226

CMYK 12/27/23/0
RGB 222/188/181

CMYK 1/3/12/0
RGB 252/243/224

CMYK 16/33/54/0
RGB 213/170/127

9FT

Megan Galante

CMYK 13/13/16/0
RGB 220/213/205

CMYK 24/42/84/3
RGB 191/145/72

CMYK 24/42/84/3
RGB 191/145/72

CMYK 3/5/9/0
RGB 246/238/227

CMYK 3/5/9/0
RGB 246/238/227

CMYK 51/61/61/33
RGB 102/80/75

CMYK 3/5/9/0
RGB 246/238/227

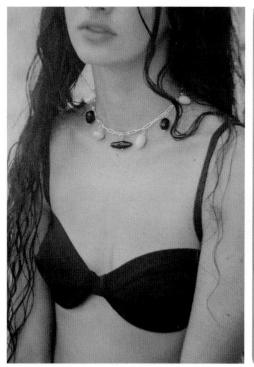

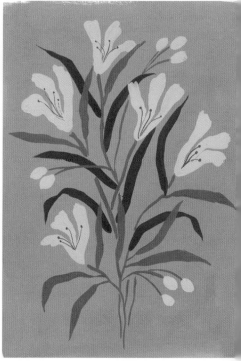

G.Binsky / Photo: Leco Moura

Megan Galante

CMYK 3U/26/61/0
RGB 183/172/120

CMYK 24/49/68/4
RGB 190/135/94

CMYK 3/3/7/0
RGB 244/240/233

CMYK 4/18/16/0
RGB 240/210/201

CMYK 6/7/11/0
RGB 237/230/221

CMYK 36/34/64/3
RGB 167/153/109

CMYK 65/58/59/39
RGB 76/75/73

CMYK 6/7/11/0
RGB 237/230/221

CMYK 30/26/61/0
RGB 183/172/120

CMYK 3/3/7/0
RGB 244/240/233

CMYK 73/56/54/34
RGB 66/80/83

CMYK 4/18/16/0
RGB 240/210/201

CMYK 23/18/28/0
RGB 199/195/180

CMYK 31/28/53/1
RGB 179/168/131

CMYK 3/3/7/0
RGB 244/240/233

CMYK 4/18/16/0
RGB 240/210/201

CMYK 30/26/61/0
RGB 183/172/120

CMYK 6/7/11/0
RGB 237/230/221

CMYK 22/34/49/0
RGB 200/165/133

CMYK 10/11/18/0
RGB 228/218/204

CMYK 4/18/16/0
RGB 240/210/201

CMYK 3/3/7/0
RGB 244/240/233

CMYK 24/49/68/4
RGB 190/135/94

CMYK 73/56/54/34
RGB 66/80/83

CMYK 65/58/59/39
RGB 76/75/73

CMYK 3/3/7/0
RGB 244/240/233

CMYK 30/26/61/0
RGB 183/172/120

CMYK 5/13/16/0
RGB 239/220/206

CMYK 12/22/25/0
RGB 224/198/183

CMYK 47/39/40/3
RGB 142/141/140

CMYK 20/28/22/0
RGB 203/180/181

CMYK 2/4/8/0
RGB 248/240/230

CMYK 11/13/15/0
RGB 225/215/208

CMYK 11/13/15/0
RGB 225/215/208

CMYK 20/28/22/0
RGB 203/180/181

CMYK 21/38/56/1
RGB 202/158/121

CMYK 2/4/8/0
RGB 248/240/230

CMYK 6/21/16/0
RGB 236/204/198

CMYK 38/51/63/10
RGB 249/118/95

CMYK 29/38/28/0
RGB 185/158/163

CMYK 11/6/7/0
RGB 225/229/230

CMYK 2/4/8/0
RGB 248/240/230

CMYK 5/13/16/0
RGB 239/220/206

CMYK 17/21/26/0
RGB 212/195/182

CMYK 2/4/8/0
RGB 248/240/230

CMYK 47/41/49/7
RGB 137/133/123

CMYK 58/52/59/27
RGB 97/94/86

CMYK 21/38/56/1
RGB 202/158/121

CMYK 2/4/8/0
RGB 248/240/230

CMYK 6/21/16/0
RGB 236/204/198

CMYK 20/28/22/0
RGB 203/180/181

CMYK 29/38/28/0
RGB 185/158/163

CMYK 11/13/15/0
RGB 225/215/208

CMYK 18/31/41/0
RGB 209/175/149

Michelle Heslop

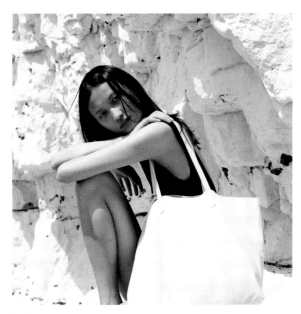

Sophia Aerts

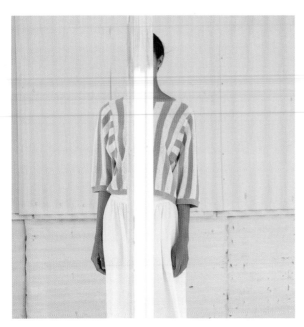

Micaela Greg / Photo: María del Río

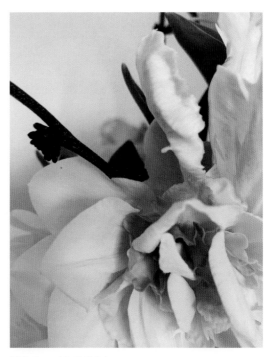

Molly Conant / Rackk & Ruin

CMYK 17/51/69/1
RGB 208/137/93

CMYK 3/24/20/0
RGB 242/200/188

CMYK 9/7/8/0
RGB 229/228/226

CMYK 5/34/59/0
RGB 238/175/118

CMYK 3/6/15/0
RGB 247/235/215

CMYK 16/2671/0
RGB 217/183/102

CMYK 3/2/5/0
RGB 245/244/238

CMYK 11/22/47/0
RGB 228/196/145

CMYK 4/10/33/0
RGB 243/223/179

CMYK 16/2671/0
RGB 217/183/102

CMYK 9/7/8/0
RGB 229/228/226

CMYK 16/2671/0
RGB 247/235/215

CMYK 4/14/22/0
RGB 241/218/196

CMYK 17/51/69/1
RGB 208/137/93

CMYK 2/44/53/0
RGB 242/160/120

CMYK 4/31/33/0
RGB 240/185/162

CMYK 17/51/69/1
RGB 208/137/93

CMYK 3/2/5/0
RGB 245/244/238

CMYK 25/17/19/0
RGB 192/196/195

CMYK 3/24/20/0
RGB 242/200/188

CMYK 2/44/53/0
RGB 242/160/120

CMYK 4/8/20/0
RGB 245/230/205

CMYK 5/34/59/0
RGB 238/175/118

CMYK 16/2671/0
RGB 247/235/215

CMYK 5/34/59/0
RGB 238/175/118

CMYK 5/14/33/0
RGB 241/216/175

CMYK 16/2671/0
RGB 217/183/102

CMYK 6/6/8/0
RGB 236/232/228

CMYK 25/13/21/0
RGB 193/203/196

CMYK 32/24/30/0
RGB 177/178/171

CMYK 12/9/12/0
RGB 222/221/216

CMYK 24/11/22/0
RGB 195/208/198

CMYK 7/10/17/0
RGB 253/233/226

CMYK 3/9/11/0
RGB 244/230/219

CMYK 21/17/21/0
RGB 202/199/193

CMYK 4/3/4/0
RGB 240/239/237

CMYK 9/4/2/0
RGB 229/234/240

CMYK 25/13/21/0
RGB 193/203/196

CMYK 12/9/12/0
RGB 222/221/216

CMYK 4/3/4/0
RGB 240/239/237

CMYK 4/10/18/0
RGB 243/225/205

CMYK 34/28/26/0
RGB 172/171/174

CMYK 33/24/25/0
RGB 173/177/178

CMYK 9/4/2/0
RGB 229/234/240

CMYK 24/11/22/0
RGB 195/208/198

CMYK 4/3/4/0
RGB 240/239/237

CMYK 3/9/11/0
RGB 244/230/219

CMYK 7/18/29/0
RGB 236/208/180

CMYK 39/28/36/0
RGB 162/168/165

CMYK 21/17/21/0
RGB 202/199/193

CMYK 9/4/2/0
RGB 229/234/240

CMYK 29/17/18/0
RGB 181/193/197

CMYK 4/3/4/0
RGB 240/239/237

CMYK 24/11/22/0
RGB 195/208/198

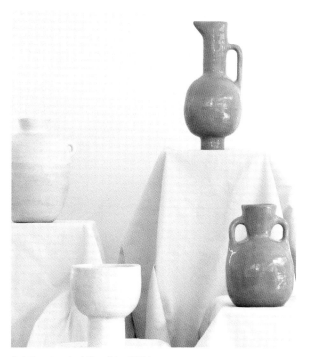

Jade Paton Ceramics / Photo: Johno Mellish

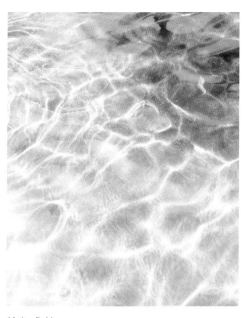

*Summer neutrals are light, **gentle** and subtle.*

Marissa Rodriguez

CMYK 14/7/39/0
RGB 220/220/170

Jennilee Marigomen

CMYK 2/4/6/0
RGB 246/240/233

CMYK 13/12/18/0
RGB 219/213/203

CMYK 0/9/8/0
RGB 254/233/225

CMYK 7/17/38/0
RGB 236/208/163

CMYK 17/22/62/0
RGB 17/22/62/0

CMYK 14/7/39/0
RGB 220/220/170

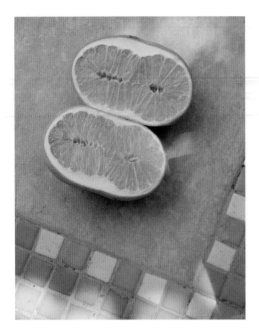

Lane Marinho

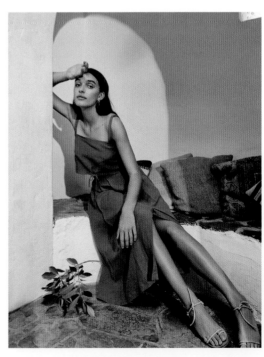

Zoe Ziecker for First Rite SS19 / Photo: Maria del Río

CMYK 6/5/9/0
RGB 238/235/228

CMYK 33/54/54/8
RGB 165/120/107

CMYK 11/33/56/0
RGB 226/175/124

CMYK 7/10/21/0
RGB 235/223/201

CMYK 22/5/15/0
RGB 198/219/214

CMYK 48/38/38/2
RGB 140/143/145

CMYK 30/38/47/11
RGB 182/153/133

CMYK 28/12/22/0
RGB 184/202/196

CMYK 7/9/16/0
RGB 236/226/210

CMYK 6/5/9/0
RGB 238/235/228

CMYK 38/50/56/11
RGB 152/120/105

CMYK 12/11/20/0
RGB 223/216/200

CMYK 15/11/15/0
RGB 214/214/208

CMYK 11/33/56/0
RGB 226/175/124

CMYK 2/7/13/0
RGB 249/234/219

CMYK 11/33/56/0
RGB 226/175/124

CMYK 7/9/16/0
RGB 236/226/210

CMYK 38/50/56/11
RGB 152/120/105

CMYK 12/16/24/0
RGB 223/208/189

CMYK 6/5/9/0
RGB 238/235/228

CMYK 17/33/60/0
RGB 213/171/118

CMYK 22/5/15/0
RGB 198/219/214

CMYK 48/38/38/2
RGB 140/143/145

CMYK 48/38/38/2
RGB 140/143/145

CMYK 55/51/50/17
RGB 114/108/107

CMYK 6/5/9/0
RGB 238/235/228

CMYK 12/11/20/0
RGB 223/216/200

CMYK 28/55/54/5
RGB 178/123/109

CMYK 16/9/13/0
RGB 212/218/214

CMYK 5/5/8/0
RGB 240/235/228

CMYK 13/29/37/0
RGB 221/183/158

CMYK 5/9/13/0
RGB 240/228/215

CMYK 25/16/17/0
RGB 191/198/200

CMYK 40/34/41/1
RGB 160/155/145

CMYK 5/5/8/0
RGB 240/235/228

CMYK 16/17/26/0
RGB 214/203/185

CMYK 11/5/9/0
RGB 225/231/228

CMYK 20/12/17/0
RGB 202/208/204

CMYK 40/34/41/1
RGB 160/155/145

CMYK 6/15/18/0
RGB 236/214/200

CMYK 33/72/73/25
RGB 141/78/64

CMYK 28/55/54/5
RGB 178/123/109

CMYK 40/34/41/1
RGB 160/155/145

CMYK 20/12/17/0
RGB 202/208/204

CMYK 16/17/26/0
RGB 214/203/185

CMYK 5/5/8/0
RGB 240/235/228

CMYK 5/5/8/0
RGB 240/235/228

CMYK 13/29/37/0
RGB 221/183/158

CMYK 28/55/54/5
RGB 178/123/109

CMYK 33/72/73/25
RGB 141/78/64

CMYK 25/16/17/0
RGB 191/198/200

CMYK 27/45/49/2
RGB 185/142/125

CMYK 5/5/8/0
RGB 240/235/228

CMYK 6/15/18/0
RGB 236/214/200

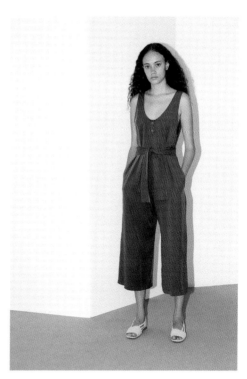

Diarte / Photo: Javier Morán

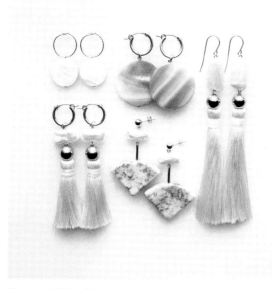

The Vamoose / Kathryn Blackmoore

S

U

M

BOLDS

Naturally, with its youthful con-
nection, summertime is filled with
bright, FUN colors. Bring on the
hot pink, neon yellow, radiant
orange, blazing red, marine aqua,
and paradise blue. If you've read
my previous book then you know
that I am all about unexpected
combinations, and this is exactly
where you should allow yourself
to be creative and have an open
mind when it comes to picking out
a color palette. Summer is lively,
it's cheerful and care-free, and
these vivid colors echo the mood
of the season.

E

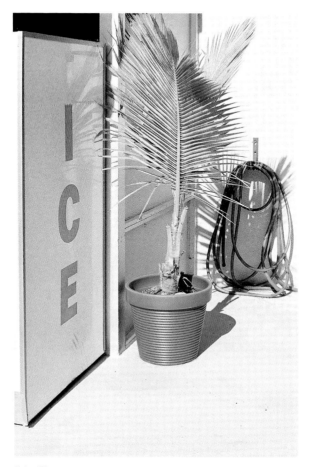

Robert Fehre

CMYK 12/2/67/0
RGB 231/229/118

CMYK 7/61/0/0
RGB 252/122/212

CMYK 65/9/17/0
RGB 78/180/203

CMYK 65/9/17/0
RGB 78/180/203

CMYK 12/2/67/0
RGB 231/229/118

CMYK 50/0/29/0
RGB 124/204/193

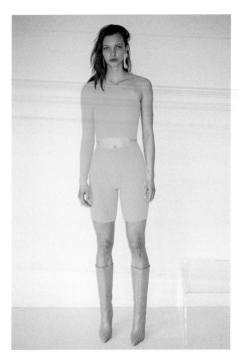

Giu Giu Ribbed Set by Bona Drag / Photo: Heather Wojner

Ilka Mészely

CMYK 0/34/4/0
RGB 251/185/204

CMYK 0/55/95/0
RGB 248/140/39

CMYK 32/0/98/0
RGB 184/214/54

CMYK 5/7/79/0
RGB 245/223/87

CMYK 0/31/90/0
RGB 252/184/55

CMYK 21/0/45/0
RGB 205/237/165

CMYK 3/2/3/0
RGB 245/245/242

CMYK 25/0/50/0
RGB 195/238/156

CMYK 33/0/98/0
RGB 184/214/54

CMYK 21/0/45/0
RGB 205/237/165

CMYK 4/71/95/0
RGB 234/108/44

CMYK 0/50/14/0
RGB 245/153/172

CMYK 2/10/90/0
RGB 254/220/52

CMYK 0/50/14/0
RGB 245/153/172

CMYK 0/55/98/0
RGB 255/140/23

CMYK 0/31/90/0
RGB 252/184/55

CMYK 0/55/95/0
RGB 248/140/39

CMYK 3/2/3/0
RGB 245/245/242

CMYK 22/11/91/0
RGB 207/203/63

CMYK 0/32/2/0
RGB 247/189/211

CMYK 2/42/83/0
RGB 244/162/69

CMYK 3/2/3/0
RGB 245/245/242

CMYK 0/55/98/0
RGB 255/140/23

CMYK 21/0/45/0
RGB 205/237/165

CMYK 24/13/94/0
RGB 202/196/57

CMYK 2/10/90/0
RGB 254/220/52

CMYK 2/42/83/0
RGB 244/162/69

CMYK 32/2/48/0
RGB 179/213/158

CMYK 61/21/24/0
RGB 103/166/182

CMYK 27/0/20/0
RGB 185/228/212

CMYK 0/58/40/0
RGB 245/135/129

CMYK 2/23/31/0
RGB 245/200/171

CMYK 59/17/78/1
RGB 117/165/99

CMYK 91/72/3/0
RGB 43/89/163

CMYK 2/23/31/0
RGB 245/200/171

CMYK 0/36/4/0
RGB 249/181/203

CMYK 0/36/4/0
RGB 249/181/203

CMYK 5/5/7/0
RGB 240/235/230

CMYK 61/2124/0
RGB 103/166/182

CMYK 5/5/7/0
RGB 240/235/230

CMYK 59/17/78/1
RGB 117/165/99

CMYK 29/0/26/0
RGB 180/222/200

CMYK 78/24/95/8
RGB 61/138/71

CMYK 61/2124/0
RGB 103/166/182

CMYK 2/23/31/0
RGB 245/200/171

CMYK 5/5/7/0
RGB 240/235/230

CMYK 5/5/7/0
RGB 240/235/230

CMYK 0/36/4/0
RGB 249/181/203

CMYK 61/2124/0
RGB 103/166/182

CMYK 91/72/3/0
RGB 43/89/163

CMYK 0/36/4/0
RGB 249/181/203

CMYK 0/58/40/0
RGB 245/135/129

CMYK 27/0/20/0
RGB 185/228/212

CMYK 5/5/7/0
RGB 240/235/230

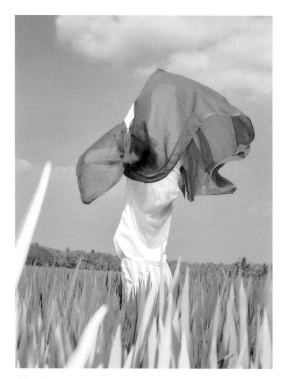

Arianna Lago

Hemphill Type Co.

Clememte Vergara

"*Keep your face to
the* **sunshine**, *and
you will never see
the* **shadows**."
-*Helen Keller*

Color Space 40, Jessica Poundstone

CMYK 10/3/61/0
RGB 234/228/131

CMYK 65/40/5/0
RGB 97/138/190

CMYK 33/8/19/0
RGB 172/205/203

CMYK 0/60/98/0
RGB 255/130/27

CMYK 1/30/93/0
RGB 250/184/46

CMYK 2/20/23/0
RGB 247/208/188

CMYK 24/33/86/10
RGB 197/163/73

CMYK 7/9/6/0
RGB 234/227/228

CMYK 0/30/90/0
RGB 254/186/49

CMYK 65/40/5/0
RGB 97/138/190

CMYK 0/60/98/0
RGB 255/130/27

CMYK 5/32/25/0
RGB 237/183/173

CMYK 6/4/3/0
RGB 237/237/240

CMYK 0/69/87/0
RGB 253/115/51

CMYK 33/8/19/0
RGB 172/205/203

CMYK 10/3/61/0
RGB 234/228/131

CMYK 0/71/94/0
RGB 252/110/38

CMYK 2/20/23/0
RGB 247/208/188

CMYK 0/53/46/0
RGB 251/145/124

CMYK 7/8/8/0
RGB 235/228/225

CMYK 45/12/27/0
RGB 142/188/185

CMYK 0/30/90/0
RGB 254/186/49

CMYK 24/33/86/10
RGB 197/163/73

CMYK 65/40/5/0
RGB 97/138/190

CMYK 0/60/98/0
RGB 255/130/27

CMYK 33/8/19/0
RGB 172/205/203

CMYK 7/8/8/0
RGB 235/228/225

Mariel Abbene

CMYK 0/39/86/0
RGB 249/168/60

CMYK 1/33/0/0
RGB 252/185/224

CMYK 8/9/12/0
RGB 233/225/217

CMYK 1/33/0/0
RGB 252/185/224

CMYK 0/89/100/0
RGB 248/63/9

CMYK 0/39/86/0
RGB 249/168/60

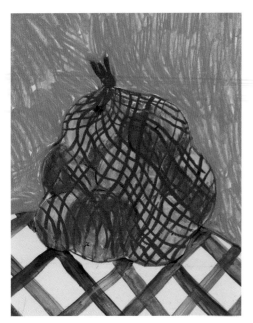

Annie Russell

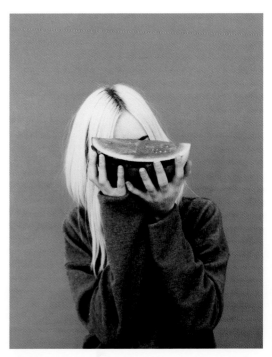

Sofie Sund

CMYK 62/46/4/0
RGB 109/130/186

CMYK 1/33/82/0
RGB 248/178/72

CMYK 36/0/44/0
RGB 166/218/168

CMYK 64/10/38/0
RGB 91/178/169

CMYK 5/48/90/0
RGB 235/148/55

CMYK 1/25/29/0
RGB 248/198/173

CMYK 64/10/38/0
RGB 91/178/169

CMYK 7/7/9/0
RGB 235/230/224

CMYK 5/48/90/0
RGB 235/148/55

CMYK 7/7/9/0
RGB 235/230/224

CMYK 36/0/44/0
RGB 166/218/168

CMYK 62/46/4/0
RGB 109/130/186

CMYK 9/64/88/1
RGB 222/118/59

CMYK 1/49/56/0
RGB 244/150/112

CMYK 7/7/9/0
RGB 235/230/224

CMYK 79/62/24/6
RGB 73/98/140

CMYK 63/0/50/0
RGB 83/198/159

CMYK 7/7/9/0
RGB 235/230/224

CMYK 36/0/44/0
RGB 166/218/168

CMYK 7/7/9/0
RGB 235/230/224

CMYK 1/33/82/0
RGB 248/178/72

CMYK 1/49/56/0
RGB 244/150/112

CMYK 13/65/80/1
RGB 214/115/70

CMYK 6/16/61/0
RGB 240/208/124

CMYK 1/33/82/0
RGB 248/178/72

CMYK 76/22/37/1
RGB 52/154/161

CMYK 13/65/80/1
RGB 214/115/70

CMYK 8/3/66/0
RGB 239/230/120

CMYK 29/0/20/0
RGB 179/225/212

CMYK 23/16/71/0
RGB 202/195/108

CMYK 1/20/26/0
RGB 251/210/183

CMYK 47/0/27/0
RGB 133/208/198

CMYK 0/80/2/0
RGB 239/90/158

CMYK 87/69/2/0
RGB 54/93/167

CMYK 16/0/16/0
RGB 214/238/220

CMYK 235/93/144
RGB 235/78/14/0

CMYK 8/3/66/0
RGB 239/230/120

CMYK 0/59/67/0
RGB 254/133/88

CMYK 0/49/35/0
RGB 255/155/143

CMYK 16/0/16/0
RGB 214/238/220

CMYK 3/23/2/0
RGB 239/203/219

CMYK 39/21/17/0
RGB 158/180/194

CMYK 23/16/71/0
RGB 202/195/108

CMYK 3/26/24/0
RGB 243/195/179

CMYK 3/2/3/0
RGB 243/243/241

CMYK 2/20/0/0
RGB 245/210/234

CMYK 0/58/67/0
RGB 253/135/90

CMYK 0/80/2/0
RGB 239/90/158

CMYK 2/5/21/0
RGB 251/237/205

CMYK 1/20/26/0
RGB 251/210/183

CMYK 6/14/1/0
RGB 235/218/233

CMYK 5/29/1/0
RGB 236/190/214

CMYK 26/12/4/0
RGB 185/206/127

CMYK 87/69/2/0
RGB 54/93/167

Leah Bartholomew

Studio RENS in collaboration with Glass Lab's Hertogenbosch

Need a New Needle

CMYK 2/44/0/0
RGB 246/163/210

CMYK 0/74/83/0
RGB 250/103/58

CMYK 3/23/20/0
RGB 243/200/188

CMYK 71/36/0/0
RGB 69/141/213

CMYK 13/86/0/0
RGB 213/70/159

CMYK 6/8/7/0
RGB 237/229/227

CMYK 6/8/7/0
RGB 237/229/227

CMYK 19/11/0/0
RGB 199/212/239

CMYK 71/36/0/0
RGB 69/141/213

CMYK 0/74/83/0
RGB 250/103/58

CMYK 2/44/0/0
RGB 246/163/210

CMYK 71/36/0/0
RGB 69/141/213

CMYK 71/36/0/0
RGB 69/141/213

CMYK 11/24/71/0
RGB 229/190/102

CMYK 2/44/0/0
RGB 246/163/210

CMYK 6/8/7/0
RGB 237/229/227

CMYK 0/74/83/0
RGB 250/103/58

CMYK 71/36/0/0
RGB 69/141/213

CMYK 16/77/99/4
RGB 202/90/42

CMYK 4/29/18
RGB 240/190/187

CMYK 0/52/0/0
RGB 251/149/202

CMYK 6/8/7/0
RGB 237/229/227

CMYK 0/74/83/0
RGB 250/103/58

CMYK 13/29/84/0
RGB 224/178/74

CMYK 13/86/0/0
RGB 213/70/159

CMYK 4/7/29/0
RGB 244/229/189

CMYK 0/52/0/0
RGB 251/149/202

Peggi Kroll Roberts

CMYK 51/7/38/0
RGB 129/190/171

CMYK 5/6/14/0
RGB 241/234/217

CMYK 22/40/100/2
RGB 200/'150/42

CMYK 5/6/14/0
RGB 241/234/217

CMYK 0/56/98/0
RGB 245/138/35

CMYK 59/13/47/0
RGB 110/176/153

CMYK 0/44/82/0
RGB 248/158/69

CMYK 5/6/14/0
RGB 241/234/217

CMYK 55/8/42/0
RGB 119/185/164

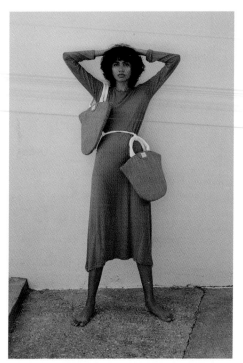

Gabriel for Sach SS21

*"It's **summer** and time for wandering."*

-Kellie Elmore

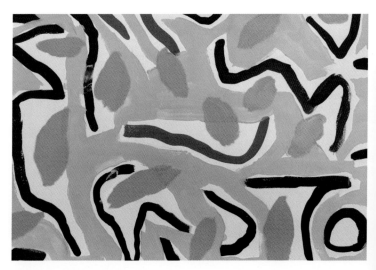

Peggi Kroll Roberts

CMYK 36/7/21/0
RGB 164/204/201

CMYK 7/4/4/0
RGB 234/236/237

CMYK 0/46/12/0
RGB 247/161/179

CMYK 7/63/26/0
RGB 227/125/144

CMYK 53/21/23/0
RGB 125/171/184

CMYK 47/40/66/12
RGB 134/128/97

CMYK 9/9/16/0
RGB 231/224/210

CMYK 36/7/21/0
RGB 164/204/201

CMYK 0/46/12/0
RGB 247/161/179

CMYK 47/40/66/12
RGB 134/128/97

CMYK 7/4/4/0
RGB 234/236/237

CMYK 60/58/74/54
RGB 67/60/45

CMYK 0/46/12/0
RGB 247/161/179

CMYK 7/63/26/0
RGB 227/125/144

CMYK 8/11/11/0
RGB 232/222/218

CMYK 7/4/4/0
RGB 234/236/237

CMYK 0/46/12/0
RGB 247/161/179

CMYK 36/7/21/0
RGB 164/204/201

CMYK 9/9/16/0
RGB 231/224/210

CMYK 7/63/26/0
RGB 227/125/144

CMYK 55/30/41/2
RGB 123/151/146

CMYK 47/40/66/12
RGB 134/128/97

CMYK 36/7/21/0
RGB 164/204/201

CMYK 9/9/16/0
RGB 231/224/210

CMYK 36/7/21/0
RGB 164/204/201

CMYK 53/21/23/0
RGB 125/171/184

CMYK 47/40/66/12
RGB 134/128/97

CMYK 5/7/8/0
RGB 240/233/227

CMYK 0/70/99/0
RGB 254/110/23

CMYK 5/44/0/0
RGB 243/160/216

CMYK 75/29/57/8
RGB 68/135/119

CMYK 0/78/62/0
RGB 239/95/90

CMYK 4/32/1/0
RGB 236/185/211

CMYK 55/0/45/0
RGB 109/205/167

CMYK 6/60/2/0
RGB 228/132/179

CMYK 78/33/57/12
RGB 56/125/114

CMYK 17/56/82/2
RGB 208/128/70

CMYK 5/7/8/0
RGB 240/233/227

CMYK 5/44/0/0
RGB 243/160/216

CMYK 5/7/8/0
RGB 240/233/227

CMYK 0/70/99/0
RGB 254/110/23

CMYK 28/0/30/0
RGB 175/255/205

CMYK 17/56/82/2
RGB 208/128/70

CMYK 5/7/8/0
RGB 240/233/227

CMYK 0/70/99/0
RGB 254/110/23

CMYK 5/44/0/0
RGB 243/160/216

CMYK 28/0/30/0
RGB 175/255/205

CMYK 0/70/99/0
RGB 254/110/23

CMYK 5/7/8/0
RGB 240/233/227

CMYK 6/60/2/0
RGB 228/132/179

CMYK 75/28/58/7
RGB 68/138/120

CMYK 51/49/77/29
RGB 107/97/66

CMYK 5/7/8/0
RGB 240/233/227

CMYK 52/0/47/0
RGB 120/207/164

Liana Jegers

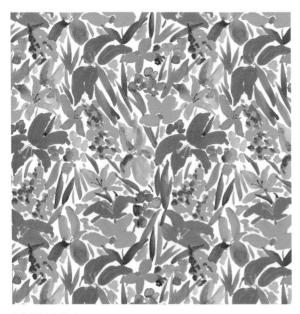

Julie T. Meeks Design

CLASSICS

I am a summer person through and through, but autumn colors have always been my absolute favorite. Those warm and earthy colors reflecting fall foliage— burnt orange, mustard, ochre, caramel, olive green—they bring on such a feeling. All seasons symbolize change, but autumn might be the most obvious as we feel the temperature shift from warm to cool, the days grow shorter, and we witness the leaves falling from the trees. The once bright colors start to fade, and we watch nature get ready for winters sleep.

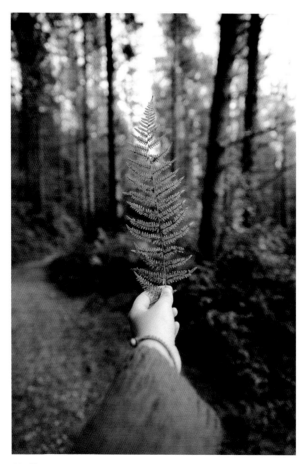

Leire Unzueta

CMYK 47/49/83/26
RGB 118/101/59

CMYK 5/6/10/0
RGB 240/233/224

CMYK 27/62/100/14
RGB 170/101/0

CMYK 37/32/65/3
RGB 165/155/109

CMYK 12/8/8/0
RGB 221/224/226

CMYK 34/82/88/43
RGB 113/48/32

93

CMYK 3/6/6/0
RGB 244/236/233

CMYK 53/59/62/34
RGB 99/81/74

CMYK 27/12/24/0
RGB 186/203/193

CMYK 14/69/80/2
RGB 209/107/69

CMYK 46/74/60/43
RGB 98/57/61

CMYK 8/15/25/0
RGB 232/212/188

CMYK 37/29/36/0
RGB 166/167/159

CMYK 30/80/97/28
RGB 141/64/34

CMYK 27/12/24/0
RGB 186/203/193

CMYK 12/28/31/0
RGB 222/185/167

CMYK 39/48/58/11
RGB 149/122/103

CMYK 70/43/62/25
RGB 77/103/90

CMYK 21/78/89/10
RGB 182/83/51

CMYK 23/9/18/0
RGB 195/210/203

CMYK 3/6/6/0
RGB 244/236/233

CMYK 46/74/60/43
RGB 98/57/61

CMYK 12/28/31/0
RGB 222/185/167

CMYK 14/69/80/2
RGB 209/107/69

CMYK 3/6/6/0
RGB 244/236/233

CMYK 41/45/41/5
RGB 151/133/133

CMYK 23/9/18/0
RGB 195/210/203

CMYK 30/80/97/28
RGB 141/64/34

CMYK 14/69/80/2
RGB 209/107/69

CMYK 23/9/18/0
RGB 195/210/203

CMYK 70/43/62/25
RGB 77/103/90

CMYK 3/6/6/0
RGB 244/236/233

CMYK 39/48/58/11
RGB 149/122/103

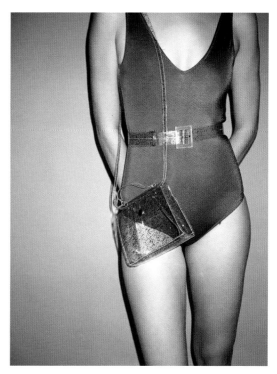

Baserange Suit & MNZ Accessories by Bona Drag / Photo: Heather Wojner

Brittany Bergamo Whalen

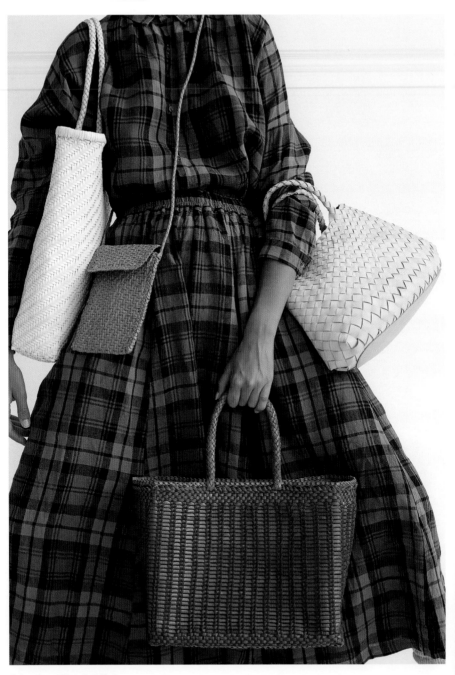

Oroboro Store / Photo: April Hughes

CMYK 23/22/14/0
RGB 195/190/199

CMYK 26/60/78/10
RGB 176/110/71

CMYK 59/57/50/23
RGB 101/93/97

CMYK 22/0/22/0
RGB 197/234/210

CMYK 20/28/32/0
RGB 206/180/165

CMYK 39/77/80/50
RGB 97/49/35

CMYK 45/49/82/25
RGB 122/103/61

CMYK 6/5/3/0
RGB 235/236/240

CMYK 22/0/22/0
RGB 197/234/210

CMYK 25/52/67/5
RGB 186/128/94

CMYK 33/78/94/36
RGB 124/60/32

CMYK 40/77/85/55
RGB 90/45/27

CMYK 6/5/3/0
RGB 235/236/240

CMYK 23/22/14/0
RGB 195/190/199

CMYK 27/58/68/9
RGB 175/114/86

CMYK 23/22/14/0
RGB 195/190/199

CMYK 59/57/50/23
RGB 101/93/97

CMYK 6/5/3/0
RGB 235/236/240

CMYK 26/60/78/10
RGB 176/110/71

CMYK 6/5/3/0
RGB 235/236/240

CMYK 20/28/32/0
RGB 206/180/165

CMYK 59/57/50/23
RGB 101/93/97

CMYK 45/49/82/25
RGB 122/103/61

CMYK 40/77/85/55
RGB 90/45/27

CMYK 28/69/83/17
RGB 161/90/57

CMYK 26/60/78/10
RGB 176/110/71

CMYK 22/0/22/0
RGB 197/234/210

CMYK 75/64/56/47
RGB 53/60/66

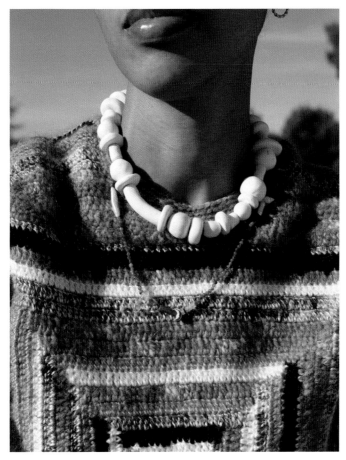

Lane Marinho

CMYK 75/64/56/47
RGB 53/60/66

CMYK 10/12/15/0
RGB 228/217/209

CMYK 29/58/82/12
RGB 168/110/65

CMYK 22/12/51/0
RGB 205/204/146

CMYK 75/64/56/47
RGB 53/60/66

CMYK 24/17/12/0
RGB 192/197/207

CMYK 29/63/98/17
RGB 160/98/41

CMYK 17/41/37/0
RGB 214/175/138

CMYK 0/17/32/2
RGB 246/210/171

CMYK 4/4/9/0
RGB 243/238/227

CMYK 17/76/86/5
RGB 199/91/58

CMYK 68/46/83/40
RGB 68/83/52

CMYK 23/56/100/7
RGB 188/119/18

CMYK 68/46/83/40
RGB 68/83/52

CMYK 15/27/65/0
RGB 219/182/112

CMYK 15/27/65/0
RGB 219/182/112

CMYK 0/17/32/2
RGB 246/210/171

CMYK 39/66/72/30
RGB 125/80/63

CMYK 6/9/17/0
RGB 238/225/208

CMYK 17/76/86/5
RGB 214/175/138

CMYK 24/71/83/13
RGB 173/93/59

CMYK 39/47/76/15
RGB 145/118/76

CMYK 0/17/32/2
RGB 246/210/171

CMYK 17/76/86/5
RGB 199/91/58

CMYK 2/30/56/0
RGB 245/186/126

CMYK 39/66/72/30
RGB 125/80/63

CMYK 15/27/65/0
RGB 219/182/112

CMYK 43/36/78/9
RGB 146/138/83

CMYK 4/4/9/0
RGB 243/238/227

CMYK 29/63/98/17
RGB 160/98/41

CMYK 4/4/9/0
RGB 243/238/227

CMYK 17/76/86/5
RGB 214/175/138

CMYK 4/4/9/0
RGB 243/238/227

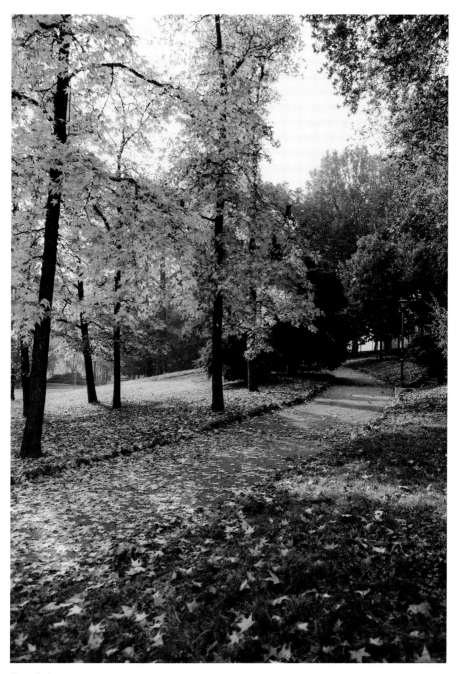

Simona Sergi

Pair Up

Andrea Serio

CMYK 29/47/100/9
RGB 174/127/27

CMYK 32/24/54/0
RGB 179/175/132

CMYK 4/6/9/0
RGB 242/235/226

CMYK 21/36/97/1
RGB 202/158/51

CMYK 30/19/77/0
RGB 185/183/95

CMYK 61/52/63/32
RGB 88/89/78

CMYK 4/11/35/0
RGB 242/220/173

CMYK 25/41/84/3
RGB 190/146/71

CMYK 39/60/100/30
RGB 126/85/18

CMYK 35/40/89/8
RGB 164/138/64

CMYK 30/19/77/0
RGB 185/183/95

CMYK 4/6/9/0
RGB 242/235/226

CMYK 18/3/6/0
RGB 206/227/232

CMYK 63/55/66/43
RGB 74/74/64

CMYK 9/30/72/0
RGB 230/179/98

CMYK 13/10/77/0
RGB 227/212/93

CMYK 4/6/9/0
RGB 242/235/226

CMYK 61/52/63/32
RGB 88/89/78

CMYK 18/3/6/0
RGB 206/227/232

CMYK 29/47/100/9
RGB 174/127/27

CMYK 21/36/97/1
RGB 202/158/51

CMYK 4/6/9/0
RGB 242/235/226

CMYK 32/24/54/0
RGB 179/175/132

CMYK 30/19/77/0
RGB 185/183/95

CMYK 4/11/35/0
RGB 242/220/173

CMYK 42/30/78/5
RGB 154/153/89

CMYK 15/22/74/0
RGB 221/190/98

CMYK 44/31/32/0
RGB 150/160/162

CMYK 43/56/97/32
RGB 117/88/39

CMYK 29/49/68/7
RGB 176/129/92

CMYK 6/13/15/0
RGB 237/219/208

CMYK 9/9/14/0
RGB 229/223/213

CMYK 22/70/82/9
RGB 182/97/63

CMYK 8/8/11/0
RGB 232/227/221

CMYK 16/56/91/2
RGB 2408/128/56

CMYK 43/56/97/32
RGB 117/88/39

CMYK 10/26/27/0
RGB 227/191/176

CMYK 44/68/87/50
RGB 92/58/32

CMYK 20/71/89/8
RGB 188/97/55

CMYK 44/31/32/0
RGB 150/160/162

CMYK 8/8/11/0
RGB 232/227/221

CMYK 43/56/97/32
RGB 117/88/39

CMYK 37/71/87/39
RGB 114/66/39

CMYK 9/21/23/0
RGB 229/201/186

CMYK 20/71/97/7
RGB 191/98/46

CMYK 8/8/11/0
RGB 232/227/221

CMYK 8/8/11/0
RGB 232/227/221

CMYK 34/69/67/23
RGB 141/83/72

CMYK 44/31/32/0
RGB 150/160/162

CMYK 20/69/89/7
RGB 191/102/56

CMYK 43/56/97/32
RGB 117/88/39

CMYK 9/24/22/0
RGB 228/195/185

CMYK 44/68/87/50
RGB 92/58/32

CMYK 29/49/68/7
RGB 176/129/92

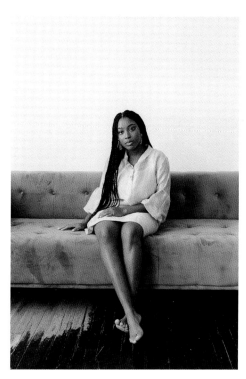

Mecoh Bain Photography

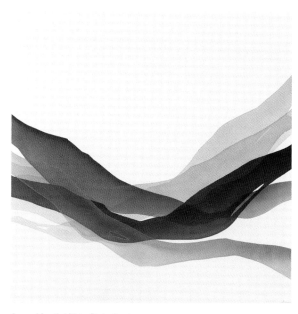

Lauren Mycroft / Photo: Dasha Armstrong

Ruhling

"*Color is a **power** which directly influences the **soul**.*"
-*Wassily Kandinsky*

Rosie Harbottle

106

CMYK 42/34/84/8
RGB 149/142/75

CMYK 76/42/66/23
RGB 60/99/84

CMYK 30/85/84/31
RGB 135/54/43

CMYK 1/36/49/0
RGB 247/175/132

CMYK 0/27/22/0
RGB 253/196/182

CMYK 68/63/53/59
RGB 72/69/76

CMYK 11/22/25/0
RGB 226/198/182

CMYK 0/30/56/0
RGB 184/128/203

CMYK 44/69/43/16
RGB 135/88/104

CMYK 69/53/64/41
RGB 66/76/68

CMYK 45/36/89/11
RGB 141/134/65

CMYK 5/9/4/0
RGB 237/228/231

CMYK 46/42/80/16
RGB 132/122/74

CMYK 45/79/63/50
RGB 91/46/51

CMYK 4/24/27/0
RGB 241/199/177

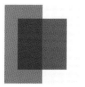

CMYK 46/42/80/16
RGB 132/122/74

CMYK 69/53/64/41
RGB 66/76/68

CMYK 5/9/4/0
RGB 237/228/231

CMYK 23/73/83/14
RGB 171/88/58

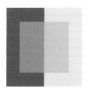

CMYK 44/69/43/16
RGB 135/88/104

CMYK 0/30/56/0
RGB 184/128/203

CMYK 5/22/24/0
RGB 231/201/183

CMYK 22/24/58/0
RGB 203/182/127

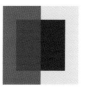

CMYK 76/42/66/23
RGB 60/99/84

CMYK 69/53/64/41
RGB 66/76/68

CMYK 4/24/27/0
RGB 241/199/177

CMYK 45/79/63/50
RGB 91/46/51

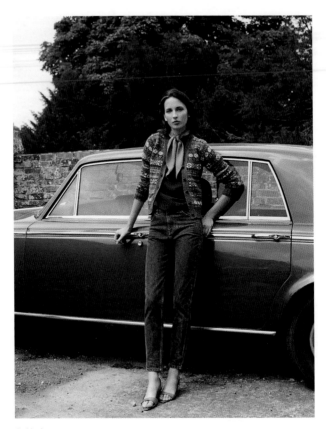

Sophia Aerts

CMYK 40/56/71/22
RGB 135/101/75

CMYK 79/49/69/44
RGB 44/75/64

CMYK 25/16/12/0
RGB 191/198/207

CMYK 25/16/12/0
RGB 191/198/207

CMYK 32/33/35/0
RGB 177/163/156

CMYK 79/49/69/44
RGB 44/75/64

CMYK 91/69/49/42
RGB 27/58/76

CMYK 22/72/76/8
RGB 185/95/70

CMYK 36/41/64/7
RGB 160/137/103

Karina Bania

CMYK 3/4/8/0
RGB 244/238/230

CMYK 4/31/31/0
RGB 239/184/164

CMYK 46/13/36/0
RGB 143/185/170

CMYK 16/9/14/0
RGB 213/218/212

CMYK 62/34/27/1
RGB 106/145/165

CMYK 90/70/42/29
RGB 38/68/94

CMYK 11/17/33/0
RGB 227/206/173

CMYK 4/7/5/0
RGB 243/233/232

CMYK 92/74/45/39
RGB 31/55/79

CMYK 73/64/60/55
RGB 49/53/56

CMYK 65/18/41/0
RGB 94/165/157

CMYK 9/6/8/0
RGB 230/230/228

CMYK 3/4/8/0
RGB 244/238/230

CMYK 73/30/49/6
RGB 72/136/130

CMYK 4/31/31/0
RGB 239/184/164

CMYK 80/32/56/11
RGB 50/126/115

CMYK 91/77/44/40
RGB 32/52/78

CMYK 3/4/8/0
RGB 244/238/230

CMYK 100/93/9/1
RGB 32/53/142

CMYK 3/4/8/0
RGB 244/238/230

CMYK 5/46/51/0
RGB 234/155/123

CMYK 4/31/31/0
RGB 239/184/164

CMYK 23/52/53/2
RGB 192/133/115

CMYK 30/17/15/0
RGB 179/193/202

CMYK 3/4/5/0
RGB 244/239/236

CMYK 71/43/75/33
RGB 67/93/68

CMYK 13/36/40/0
RGB 220/170/147

CMYK 40/75/62/34
RGB 118/65/67

CMYK 21/12/61/0
RGB 206/203/128

CMYK 30/33/62/2
RGB 182/160/115

CMYK 68/59/53/34
RGB 75/78/83

CMYK 0/17/23/0
RGB 252/215/190

CMYK 51/996/40/27
RGB 114/35/83

CMYK 27/63/79/13
RGB 168/103/67

CMYK 33/100/76/47
RGB 109/1/33

CMYK 8/6/9/0
RGB 233/232/227

CMYK 46/73/51/26
RGB 120/74/85

CMYK 17/25/57/0
RGB 213/184/127

CMYK 0/17/23/0
RGB 252/215/190

CMYK 12/11/11/0
RGB 222/218/216

CMYK 68/59/53/34
RGB 75/78/83

CMYK 38/25/28/0
RGB 163/173/173

CMYK 68/59/53/34
RGB 75/78/83

CMYK 49/80/71/71
RGB 61/25/25

CMYK 5/19/17/0
RGB 238/208/199

CMYK 27/63/79/13
RGB 168/103/67

CMYK 68/59/53/34
RGB 75/78/83

CMYK 22/55/21/0
RGB 198/133/158

CMYK 8/6/9/0
RGB 233/232/227

CMYK 7/45/33/0
RGB 229/156/149

CMYK 17/25/57/0
RGB 213/184/127

CMYK 38/25/28/0
RGB 163/173/173

CMYK 42/90/60/53
RGB 161/82/106

CMYK 42/93/65/61
RGB 83/0/30

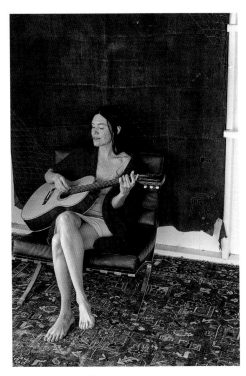

Erica Tanov / Photo: Mikael Kennedy

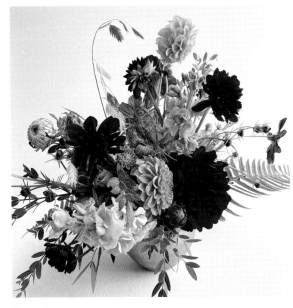

Jewelweed

A U T U M N

NEUTRALS

Fall Neutrals tend to be deeper and moodier than the spring/ summer neutrals. They feel a bit more organic and rustic. Think rich khaki, cedar brown, mossy green, and navy blue. For some lighter neutrals—try wheat, ivory, camel, or a dull, dusty pink (this color belongs just about anywhere in my opinion). Imagine the light on a cool crisp autumn morning, a walk in the woods, a smoky camp-fire—if you pull out the neutral colors from these visualizations you're sure to create a beautiful, natural autumn palette.

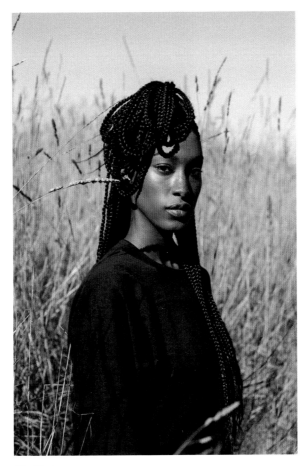

Aliya Wanek

CMYK 84/74/47/43
RGB 45/53/75

CMYK 9/9/11/0
RGB 228/223/218

CMYK 57/53/69/37
RGB 88/82/66

CMYK 10/7/5/0
RGB 225/228/232

CMYK 42/64/78/38
RGB 110/74/52

CMYK 32/37/53/2
RGB 176/152/124

CMYK 0/5/10/0
RGB 255/241/225

CMYK 24/57/70/6
RGB 186/120/86

CMYK 35/70/84/33
RGB 126/73/47

CMYK 7/29/28/0
RGB 234/188/172

CMYK 10/24/38/0
RGB 229/193/159

CMYK 39/51/86/20
RGB 129/108/58

CMYK 8/39/48/0
RGB 229/165/132

CMYK 0/78/93/40
RGB 160/66/22

CMYK 0/5/10/0
RGB 255/241/225

CMYK 39/51/86/20
RGB 129/108/58

CMYK 0/20/29/0
RGB 253/210/177

CMYK 17/47/74/1
RGB 208/143/88

CMYK 39/56/52/12
RGB 148/111/105

CMYK 1/14/24/0
RGB 253/221/191

CMYK 7/29/28/0
RGB 234/188/172

CMYK 39/56/52/12
RGB 148/111/105

CMYK 35/70/84/33
RGB 126/73/47

CMYK 0/20/29/0
RGB 253/210/177

CMYK 24/57/70/6
RGB 186/120/86

CMYK 8/39/48/0
RGB 229/165/132

CMYK 17/47/74/1
RGB 208/143/88

CMYK 7/29/28/0
RGB 234/188/172

CMYK 0/5/10/0
RGB 255/241/225

CMYK 39/51/86/20
RGB 129/108/58

CMYK 0/20/29/0
RGB 253/210/177

CMYK 35/70/84/33
RGB 126/73/47

CMYK 17/47/74/1
RGB 208/143/88

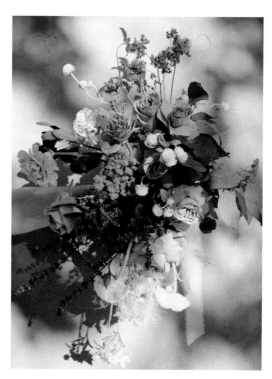

Florals: Vessel & Stem / Photo: Amaris Sachs Photo

Lauren Sterrett

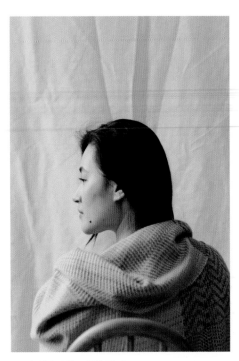

Botanical Inks / Photo: Silkie Lloyd

Lauren Sterrett

CMYK 38/38/71/8
RGB 156/140/94

CMYK 3/4/8/0
RGB 244/238/230

CMYK 56/74/56/18
RGB 110/110/100

CMYK 12/12/17/0
RGB 223/215/204

CMYK 19/39/48/0
RGB 205/160/146

CMYK 22/18/22/0
RGB 199/196/189

CMYK 12/12/17/0
RGB 223/215/204

CMYK 37/58/62/36
RGB 90/80/73

CMYK 19/39/48/0
RGB 205/160/146

CMYK 38/38/71/8
RGB 156/140/94

CMYK 15/28/29/0
RGB 215/183/170

CMYK 3/4/8/0
RGB 244/238/230

CMYK 52/47/80/27
RGB 109/101/64

CMYK 33/50/64/9
RGB 165/124/96

CMYK 33/50/64/9
RGB 165/124/96

CMYK 37/58/62/36
RGB 90/80/73

CMYK 19/39/48/0
RGB 205/160/146

CMYK 12/12/17/0
RGB 223/215/204

CMYK 33/50/64/9
RGB 165/124/96

CMYK 3/4/8/0
RGB 244/238/230

CMYK 38/38/71/8
RGB 156/140/94

CMYK 3/4/8/0
RGB 244/238/230

CMYK 38/38/71/8
RGB 156/140/94

CMYK 22/18/22/0
RGB 199/196/189

CMYK 22/18/22/0
RGB 199/196/189

CMYK 52/47/80/27
RGB 109/101/64

CMYK 52/47/80/27
RGB 109/101/64

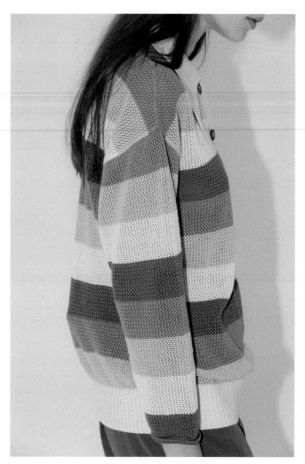

Diarte / Photo: Javier Morán

CMYK 22/50/65/3
RGB 195/135/99

CMYK 15/17/25/0
RGB 217/203/186

CMYK 56/42/63/18
RGB 110/115/94

CMYK 5/5/10/0
RGB 239/235/225

CMYK 56/42/63/18
RGB 110/115/94

CMYK 22/50/65/3
RGB 195/135/99

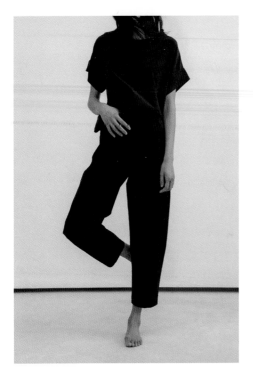

Elizabeth Suzann

"The **soul** *becomes dyed with the color of its* **thoughts.***"*
-Marcus Aurelius

h o u s e \ \ w e a v i n g

CMYK 6/20/24/0
RGB 235/203/185

CMYK 100/81/26/11
RGB 25/68/121

CMYK 26/32/57/1
RGB 190/165/122

CMYK 17/40/83/1
RGB 211/156/74

CMYK 7/5/10/0
RGB 235/233/225

CMYK 76/62/49/34
RGB 62/74/86

CMYK 76/62/49/34
RGB 62/74/86

CMYK 7/5/10/0
RGB 235/233/225

CMYK 17/40/83/1
RGB 211/156/74

CMYK 8/8/10/0
RGB 233/228/223

CMYK 18/22/43/0
RGB 211/190/152

CMYK 100/81/26/11
RGB 25/68/121

CMYK 25/64/95/12
RGB 174/103/47

CMYK 6/20/24/0
RGB 235/203/185

CMYK 6/20/24/0
RGB 235/203/185

CMYK 7/5/10/0
RGB 235/233/225

CMYK 91/76/45/42
RGB 32/52/76

CMYK 25/64/95/12
RGB 174/103/47

CMYK 76/62/49/34
RGB 62/74/86

CMYK 30/36/68/3
RGB 179/153/102

CMYK 33/64/90/24
RGB 143/90/46

CMYK 18/22/43/0
RGB 211/190/152

CMYK 100/81/26/11
RGB 25/68/121

CMYK 7/5/10/0
RGB 235/233/225

CMYK 17/40/83/1
RGB 211/156/74

CMYK 9/27/31/0
RGB 229/188/167

CMYK 5/30/38/0
RGB 238/185/154

CMYK 47/57/62/26
RGB 118/93/82

CMYK 8/9/13/0
RGB 231/224/215

CMYK 19/20/29/0
RGB 207/195/178

CMYK 30/65/84/19
RGB 154/93/57

CMYK 74/67/61/67
RGB 37/38/42

CMYK 28/46/39/1
RGB 186/158/132

CMYK 8/9/13/0
RGB 231/224/215

CMYK 31/31/29/0
RGB 179/168/167

CMYK 45/34/60/20
RGB 128/103/90

CMYK 31/51/77/11
RGB 165/120/76

CMYK 74/67/61/67
RGB 37/38/42

CMYK 18/20/30/0
RGB 210/195/176

CMYK 8/9/13/0
RGB 231/224/215

CMYK 29/44/100/8
RGB 176/133/30

CMYK 30/65/84/19
RGB 154/93/57

CMYK 48/65/69/45
RGB 93/65/55

CMYK 40/53/70/19
RGB 139/107/79

CMYK 33/75/99/33
RGB 130/67/30

CMYK 18/20/30/0
RGB 210/195/176

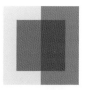

CMYK 8/9/13/0
RGB 231/224/215

CMYK 31/51/77/11
RGB 165/120/76

CMYK 29/44/100/8
RGB 176/133/30

CMYK 30/65/84/19
RGB 154/93/57

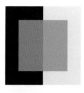

CMYK 74/67/61/67
RGB 37/38/42

CMYK 29/44/100/8
RGB 176/133/30

CMYK 8/9/13/0
RGB 231/224/215

CMYK 0/67/61/0
RGB 249/118/95

Hanna

Ruby Bell Ceramics

Jasmine Dowling

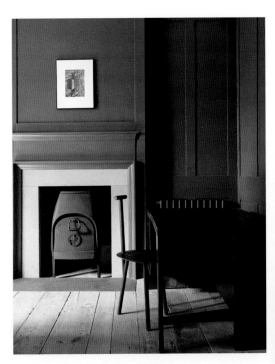

The New Road Residence by Blue Mountain School

CMYK 15/31/37/0
RGB 217/178/156

CMYK 34/84/96/46
RGB 109/43/21

CMYK 36/46/94/13
RGB 155/122/53

CMYK 5/20/29/0
RGB 238/204/177

CMYK 27/72/100/19
RGB 161/83/8

CMYK 1/3/7/0
RGB 250/243/233

CMYK 16/38/98/1
RGB 214/158/45

CMYK 64/49/56/21
RGB 92/100/95

CMYK 1/3/7/0
RGB 250/243/233

CMYK 41/79/78/61
RGB 80/36/28

CMYK 42/79/78/61
RGB 249/118/95

CMYK 5/20/29/0
RGB 238/204/177

CMYK 1/3/7/0
RGB 250/243/233

CMYK 36/46/94/13
RGB 155/122/53

CMYK 12/23/30/0
RGB 223/195/173

CMYK 36/46/94/13
RGB 155/122/53

CMYK 46/73/75/59
RGB 77/44/35

CMYK 1/3/7/0
RGB 250/243/233

CMYK 27/72/100/19
RGB 161/83/8

CMYK 27/72/100/19
RGB 161/83/8

CMYK 15/31/37/0
RGB 217/178/156

CMYK 5/33/42/0
RGB 237/180/145

CMYK 1/3/7/0
RGB 250/243/233

CMYK 41/79/78/61
RGB 80/36/28

CMYK 1/3/7/0
RGB 250/243/233

CMYK 36/46/94/13
RGB 155/122/53

CMYK 15/31/37/0
RGB 217/178/156

CMYK 44/41/40/3
RGB 148/140/138

CMYK 6/5/7/0
RGB 237/234/230

CMYK 21/40/90/2
RGB 203/153/62

CMYK 61/57/49/230
RGB 97/92/98

CMYK 39/44/73/13
RGB 148/125/84

CMYK 35/53/68/14
RGB 153/113/85

CMYK 6/5/7/0
RGB 237/234/230

CMYK 63/59/53/30
RGB 88/83/87

CMYK 37/35/60/4
RGB 163/150/114

CMYK 28/33/65/2
RGB 185/160/109

CMYK 10/9/14/0
RGB 228/223/213

CMYK 10/9/14/0
RGB 228/223/213

CMYK 19/22/44/0
RGB 208/189/150

CMYK 23/27/56/0
RGB 200/178/129

CMYK 61/57/49/230
RGB 97/92/98

CMYK 61/63/62/60
RGB 70/60/58

CMYK 16/37/87/6
RGB 203/153/62

CMYK 6/5/7/0
RGB 237/234/230

CMYK 28/33/65/2
RGB 185/160/109

CMYK 40/43/79/13
RGB 146/125/76

CMYK 63/59/53/30
RGB 88/83/87

CMYK 50/50/47/13
RGB 125/114/114

CMYK 14/13/34/9
RGB 218/209/173

CMYK 10/9/14/0
RGB 228/223/213

CMYK 10/9/14/0
RGB 228/223/213

CMYK 29/36/79/3
RGB 181/152/84

CMYK 33/30/29/0
RGB 175/168/168

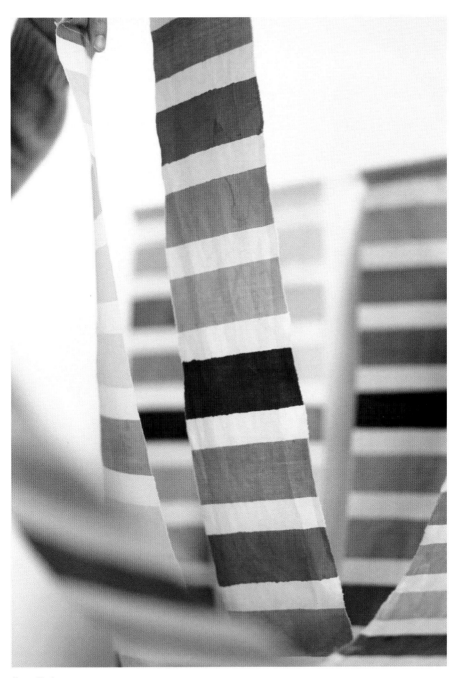

Joanna Fowles

CMYK 42/44/77/15
RGB 141/122/78

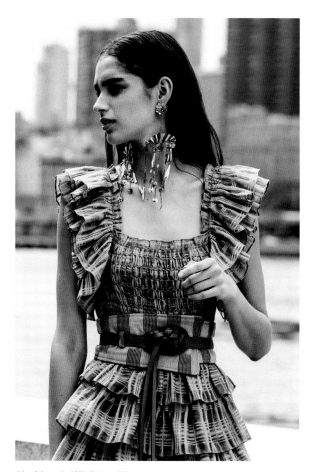

Nina Westervelt / Ulla Johnson SS21

CMYK 42/44/77/15
RGB 141/122/78

CMYK 20/17/21/0
RGB 205/200/193

CMYK 18/29/53/0
RGB 211/177/132

CMYK 22/72/91/10
RGB 183/93/51

CMYK 69/64/61/58
RGB 52/51/50

CMYK 42/44/77/15
RGB 141/122/78

131

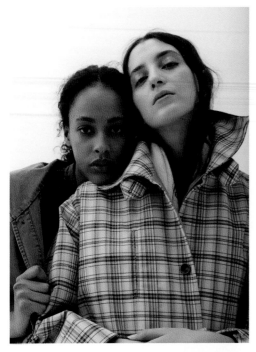

*"Another **fall**, another turned page..."*

-Wallace Stegner

Caron Callahan Resort 2020 / Photo: Josefina Santos

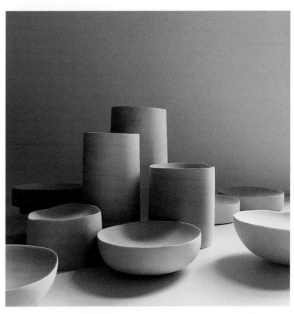

Luke Hope

CMYK 35/40/50/3
RGB 167/144/125

CMYK 8/10/13/0
RGB 233/224/215

CMYK 14/14/30/0
RGB 218/208/180

CMYK 68/56/29/7
RGB 97/103/138

CMYK 33/45/40/2
RGB 172/140/138

CMYK 49/68/62/41
RGB 97/66/64

CMYK 19/34/33/0
RGB 207/169/158

CMYK 9/9/11/0
RGB 228/223/218

CMYK 76/69/52/49
RGB 51/53/65

CMYK 49/68/62/41
RGB 97/66/64

CMYK 12/27/27/0
RGB 222/188/175

CMYK 9/8/9/0
RGB 230/226/223

CMYK 8/10/13/0
RGB 233/224/215

CMYK 39/42/46/4
RGB 158/138/128

CMYK 14/14/30/0
RGB 218/208/180

CMYK 68/56/29/7
RGB 97/103/138

CMYK 76/69/52/49
RGB 51/53/65

CMYK 9/9/11/0
RGB 228/223/218

CMYK 30/38/48/2
RGB 180/152/130

CMYK 35/40/50/3
RGB 167/144/125

CMYK 9/9/11/0
RGB 228/223/218

CMYK 33/45/40/2
RGB 172/140/138

CMYK 49/68/62/41
RGB 97/66/64

CMYK 8/10/13/0
RGB 233/224/215

CMYK 76/69/52/49
RGB 51/53/65

CMYK 35/40/50/3
RGB 167/144/125

CMYK 14/14/30/0
RGB 249/118/95

CMYK 9/6/8/0
RGB 230/230/228

CMYK 50/46/60/17
RGB 122/115/97

CMYK 29/44/46/2
RGB 183/143/130

CMYK 42/67/68/34
RGB 116/75/64

CMYK 43/68/77/45
RGB 99/62/45

CMYK 15/8/6/0
RGB 214/222/228

CMYK 30/24/24/0
RGB 181/180/181

CMYK 43/41/58/9
RGB 146/133/109

CMYK 11/11/13/0
RGB 223/218/213

CMYK 53/47/62/21
RGB 112/108/91

CMYK 30/24/24/0
RGB 181/180/181

CMYK 15/8/6/0
RGB 214/222/228

CMYK 78/68/59/68
RGB 31/36/42

CMYK 40/23/20/0
RGB 156/175/187

CMYK 11/8/10/0
RGB 223/223/221

CMYK 29/44/46/2
RGB 183/143/130

CMYK 42/67/68/34
RGB 116/75/64

CMYK 8/6/6/0
RGB 230/230/231

CMYK 50/68/72/59
RGB 78/48/39

CMYK 11/11/13/0
RGB 223/218/213

CMYK 50/46/60/17
RGB 122/115/97

CMYK 78/68/59/68
RGB 31/36/42

CMYK 42/67/68/34
RGB 116/75/64

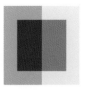

CMYK 33/26/28/0
RGB 175/175/173

CMYK 42/67/68/34
RGB 116/75/64

CMYK 9/6/8/0
RGB 230/230/228

CMYK 42/39/57/7
RGB 150/149/113

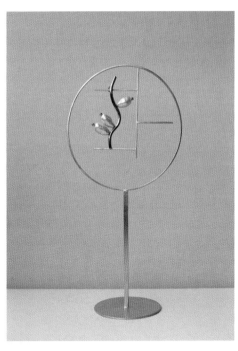

Stand and Earrings: Beaufille / Photo: Sarah Blais

Clothing amd Accessories: Beaufille / Photo:
Sarah Blais / Styling: Monika Tatalovic
Model: Charlotte Carey / Hair and
Makeup: Adam Garland

BOLDS

Vibrant, vivid colors are regularly correlated with the autumn season. The fall harvest brings on these colors in its fruits; apples, bananas, berries—and vegetables; beets, radishes, carrots and bell peppers. We see a lot of ruby reds, oranges, emerald greens, and purples… but this is a time where, again, I see an opportunity to throw in pops of unpredictable colors. Fuscia, royal blue, powder blue, or intense turquoise—these all go well when paired with the down-to-earth hues of fall.

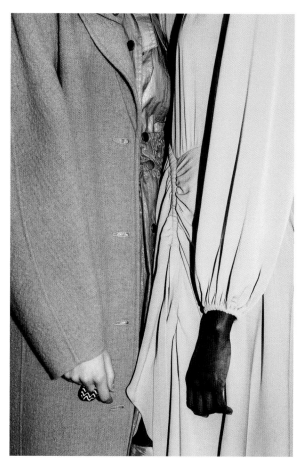

Nina Westervelt / Ulla Johnson FW20

CMYK 5/24/82/0
RGB 241/193/76

CMYK 48/71/68/55
RGB 80/49/45

CMYK 48/71/68/55
RGB 80/49/45

CMYK 17/67/98/4
RGB 200/107/43

CMYK 27/51/100/9
RGB 177/122/24

CMYK 2/15/25/0
RGB 248/217/189

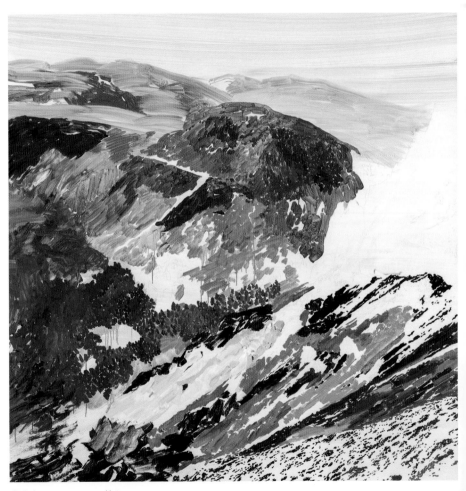

郭志宏 *Chih-Hung KUO*, "某山16 *A Mountain16*", *150 x 150 cm, oil on canvas, 2015*

CMYK 14/2/14/0
RGB 219/233/221

■ **CMYK** 38/69/47/13
RGB 150/93/103

■ **CMYK** 70/51/58/31
RGB 73/88/84

■ **CMYK** 21/18/40/0
RGB 204/195/160

■ **CMYK** 2/29/36/0
RGB 245/190/158

■ **CMYK** 50/37/84/14
RGB 127/128/70

CMYK 8/8/12/0
RGB 232/227/219

■ **CMYK** 38/69/47/13
RGB 150/93/103

■ **CMYK** 54/64/63/45
RGB 85/65/61

■ **CMYK** 28/21/58/0
RGB 190/184/130

CMYK 8/8/12/0
RGB 232/227/219

■ **CMYK** 53/69/66/56
RGB 73/50/47

■ **CMYK** 27/38/67/2
RGB 187/153/104

■ **CMYK** 70/55/55/32
RGB 73/83/85

CMYK 13/2/13/0
RGB 221/234/223

CMYK 11/7/24/0
RGB 227/225/198

■ **CMYK** 70/51/58/31
RGB 73/88/84

■ **CMYK** 2/29/36/0
RGB 245/190/158

■ **CMYK** 22/29/81/0
RGB 202/172/83

■ **CMYK** 34/68/51/12
RGB 157/95/99

■ **CMYK** 0/67/61/0
RGB 249/118/95

CMYK 4/0/9/0
RGB 242/246/233

■ **CMYK** 55/40/83/20
RGB 111/116/67

CMYK 8/8/12/0
RGB 232/227/219

■ **CMYK** 28/3/14/0
RGB 182/217/216

■ **CMYK** 66/47/58/25
RGB 85/100/92

■ **CMYK** 30/36/67/3
RGB 181/154/105

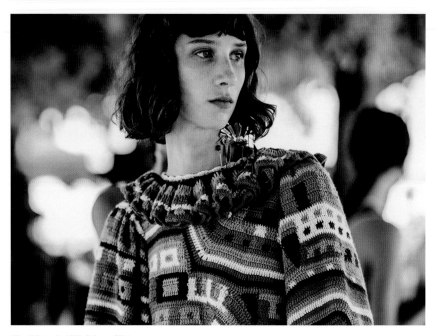

Nina Westervelt / Ulla Johnson SS21

CMYK 54/10/26/0
RGB 117/185/188

CMYK 21/81/100/11
RGB 181/76/29

CMYK 73/77/48/46
RGB 60/48/68

CMYK 83/32/32/2
RGB 15/136/157

CMYK 9/71/100/1
RGB 222/104/14

CMYK 100/73/36/21
RGB 0/70/106

CMYK 8/77/0/0
RGB 223/95/165

CMYK 16/25/90/0
RGB 217/183/63

CMYK 0/38/0/0
RGB 248/178/213

CMYK 47/64/74/46
RGB 93/65/49

CMYK 59/73/35/15
RGB 111/80/112

CMYK 13/14/23/0
RGB 221/210/193

CMYK 55/72/63/60
RGB 68/44/45

CMYK 31/48/70/8
RGB 169/128/88

CMYK 2/49/5/0
RGB 239/154/185

CMYK 27/36/98/3
RGB 188/154/49

CMYK 34/63/78/23
RGB 142/91/62

CMYK 11/3/22/0
RGB 228/232/204

CMYK 8/77/0/0
RGB 223/95/165

CMYK 7/8/12/0
RGB 235/228/218

CMYK 52/68/55/35
RGB 100/71/76

CMYK 59/73/35/15
RGB 111/80/112

CMYK 8/77/0/0
RGB 223/95/165

CMYK 13/14/23/0
RGB 221/210/193

CMYK 2/49/5/0
RGB 239/154/185

CMYK 7/8/12/0
RGB 235/228/218

CMYK 16/25/90/0
RGB 217/183/63

CMYK 8/77/0/0
RGB 223/95/165

CMYK 34/63/78/23
RGB 142/91/62

CMYK 55/72/63/60
RGB 68/44/45

CMYK 11/3/22/0
RGB 228/232/204

CMYK 31/48/70/8
RGB 169/128/88

CMYK 27/36/98/3
RGB 188/154/49

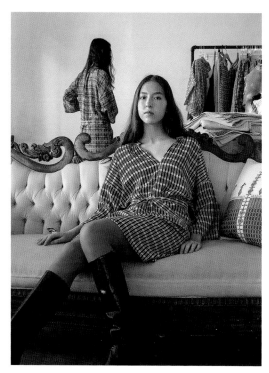

Erica Tanov / Photo: Gabrielle Stiles

Georgie Home

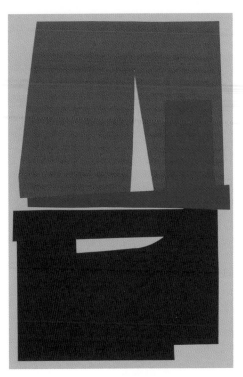

Marie Bernard

*"**Nature** gives to every time and season some **beauties** of its own."*

-Hans Hoffman

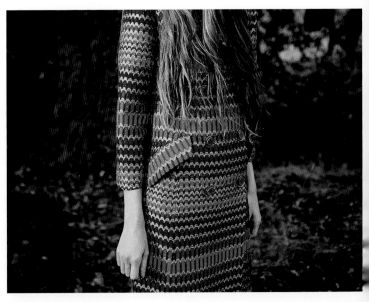

Erica Tanov / Photo: Terri Loewenthal

CMYK 7/7/11/0
RGB 234/230/221

CMYK 85/50/2/0
RGB 50/105/175

CMYK 35/88/78/46
RGB 107/37/37

CMYK 0/62/86/0
RGB 255/127/53

CMYK 2/63/39/0
RGB 239/126/128

CMYK 76/54/64/47
RGB 49/68/63

CMYK 76/54/64/47
RGB 49/68/63

CMYK 6/12/17/0
RGB 238/221/205

CMYK 2/63/39/0
RGB 239/126/128

CMYK 85/50/2/0
RGB 50/105/175

CMYK 35/88/78/46
RGB 107/37/37

CMYK 7/57/25/0
RGB 228/136/151

CMYK 7/7/11/0
RGB 234/230/221

CMYK 85/50/2/0
RGB 50/105/175

CMYK 0/62/86/0
RGB 255/127/53

CMYK 0/62/86/0
RGB 255/127/53

CMYK 51/70/85/68
RGB 63/36/9

CMYK 6/12/17/0
RGB 238/221/205

CMYK 7/57/25/0
RGB 228/136/151

CMYK 76/54/64/47
RGB 49/68/63

CMYK 16/75/95/4
RGB 200/93/47

CMYK 42/61/89/36
RGB 113/79/42

CMYK 6/12/17/0
RGB 238/221/205

CMYK 85/50/2/0
RGB 50/105/175

CMYK 76/54/64/47
RGB 49/68/63

CMYK 7/7/11/0
RGB 249/118/95

CMYK 0/62/86/0
RGB 255/127/53

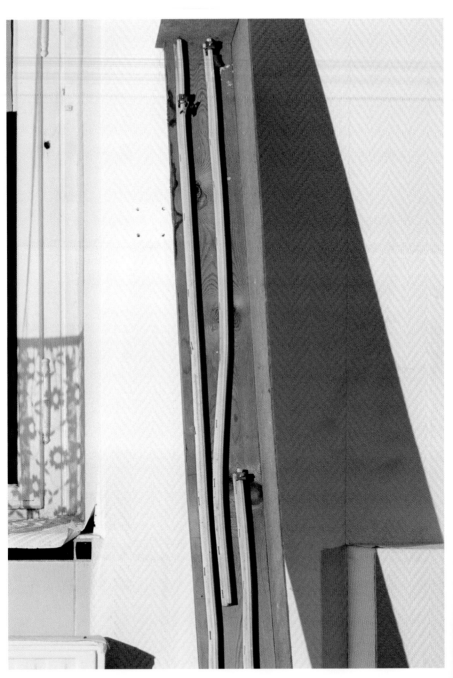

Andrea Grützner

CMYK 4/33/84/0
RGB 241/177/69

CMYK 35/70/6/0
RGB 171/103/162

CMYK 72/68/67/88
RGB 6/2/1

CMYK 20/3/8/0
RGB 200/223/228

CMYK 3/2/4/0
RGB 244/243/239

CMYK 19/67/100/7
RGB 194/102/0

CMYK 19/67/100/7
RGB 194/102/0

CMYK 72/68/67/88
RGB 6/2/1

CMYK 5/8/20/0
RGB 241/228/203

CMYK 3/2/4/0
RGB 244/243/239

CMYK 39/66/86/36
RGB 116/73/43

CMYK 35/70/6/0
RGB 171/103/162

CMYK 35/70/6/0
RGB 171/103/162

CMYK 20/3/8/0
RGB 200/223/228

CMYK 11/38/96/0
RGB 225/162/46

CMYK 39/66/86/36
RGB 116/73/43

CMYK 19/67/100/7
RGB 194/102/0

CMYK 3/2/4/0
RGB 244/243/239

CMYK 35/70/6/0
RGB 171/103/162

CMYK 35/70/6/0
RGB 171/103/162

CMYK 5/8/20/0
RGB 241/228/203

CMYK 72/68/67/88
RGB 6/2/1

CMYK 20/3/8/0
RGB 200/223/228

CMYK 11/38/96/0
RGB 225/162/46

CMYK 40/66/31/4
RGB 157/104/130

CMYK 5/8/20/0
RGB 241/228/203

CMYK 39/66/86/36
RGB 116/73/43

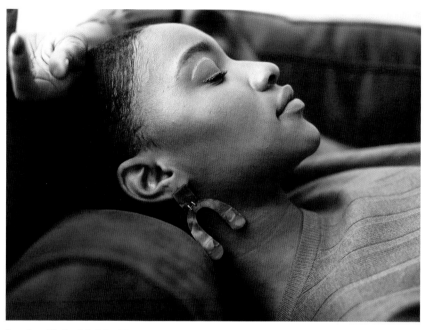

Lawn Party / Styling: Julie Fuller / Photo: Alison Vagnini / Model: Taryn Vaughn

CMYK 11/34/80/0
RGB 227/170/79

CMYK 84/53/34/11
RGB 49/103/130

CMYK 80/44/70/35
RGB 45/88/73

CMYK 15/62/87/2
RGB 207/118/60

CMYK 86/63/45/29
RGB 45/75/94

CMYK 4/11/16/0
RGB 242/223/207

CMYK 8/10/14/0
RGB 233/223/212

CMYK 71/41/60/20
RGB 77/110/98

CMYK 22/50/73/4
RGB 193/133/87

CMYK 10/26/4/0
RGB 225/193/212

CMYK 31/27/67/1
RGB 182/170/111

CMYK 24/78/34/1
RGB 191/90/122

CMYK 4/42/0/0
RGB 245/165/218

CMYK 37/79/68/37
RGB 118/58/57

CMYK 26/55/78/8
RGB 180/120/75

CMYK 77/46/68/36
RGB 53/86/73

CMYK 31/27/67/1
RGB 182/170/111

CMYK 27/78/42/4
RGB 181/86/110

CMYK 22/73/86/11
RGB 179/90/56

CMYK 10/26/4/0
RGB 225/193/212

CMYK 8/10/14/0
RGB 233/223/212

CMYK 31/27/67/1
RGB 182/170/111

CMYK 71/41/60/20
RGB 77/110/98

CMYK 8/10/14/0
RGB 233/223/212

CMYK 24/78/34/1
RGB 191/90/122

CMYK 37/79/68/37
RGB 118/58/57

CMYK 9/53/58/0
RGB 225/140/109

CMYK 24/78/34/1
RGB 191/90/122

CMYK 10/26/4/0
RGB 225/193/212

CMYK 22/73/86/11
RGB 179/90/56

CMYK 4/42/0/0
RGB 245/165/218

CMYK 71/41/60/20
RGB 77/110/98

CMYK 8/10/14/0
RGB 233/223/212

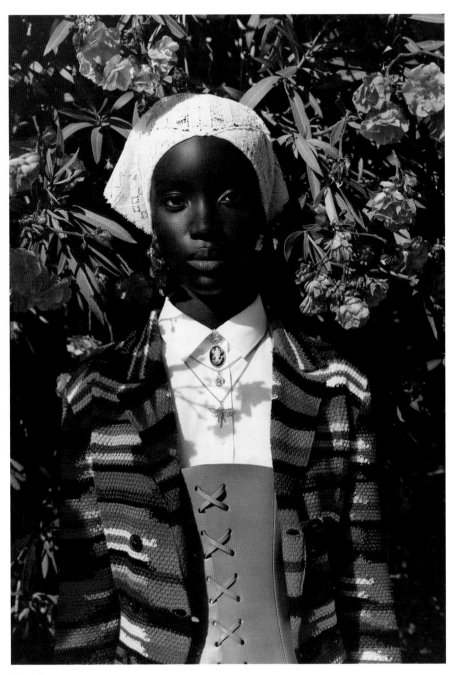

Arianna Lago

Annie Spratt

"*I think that to one in sympathy with* **nature***, each season, in turn, seems the* **loveliest**.*"*
-*Mark Twain*

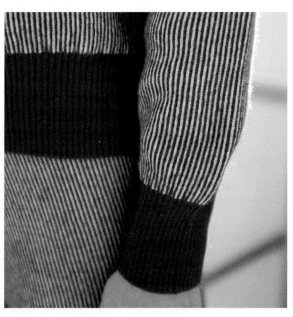

Beklina

CMYK 14/62/82/2
RGB 212/120/69

CMYK 33/81/86/37
RGB 122/55/38

CMYK 9/14/55/0
RGB 234/210/137

CMYK 38/88/27/4
RGB 160/65/119

CMYK 51/69/48/26
RGB 113/78/90

CMYK 18/82/76/6
RGB 193/78/69

CMYK 8/7/6/0
RGB 230/228/230

CMYK 38/88/27/4
RGB 160/65/119

CMYK 21/79/100/10
RGB 182/80/32

CMYK 33/81/86/37
RGB 122/55/38

CMYK 9/14/55/0
RGB 234/210/137

CMYK 14/76/0/0
RGB 211/97/167

CMYK 13/36/15/0
RGB 218/170/183

CMYK 41/81/68/53
RGB 91/41/43

CMYK 21/79/100/10
RGB 182/80/32

CMYK 42/78/64/45
RGB 100/52/55

CMYK 18/91/96/8
RGB 189/56/42

CMYK 38/88/27/4
RGB 160/65/119

CMYK 14/62/82/2
RGB 212/120/69

CMYK 8/7/6/0
RGB 230/228/230

CMYK 14/62/82/2
RGB 212/120/69

CMYK 14/76/0/0
RGB 211/97/167

CMYK 33/81/86/37
RGB 122/55/38

CMYK 14/62/82/2
RGB 212/120/69

CMYK 38/88/27/4
RGB 160/65/119

CMYK 13/36/15/0
RGB 218/170/183

CMYK 41/81/68/53
RGB 91/41/43

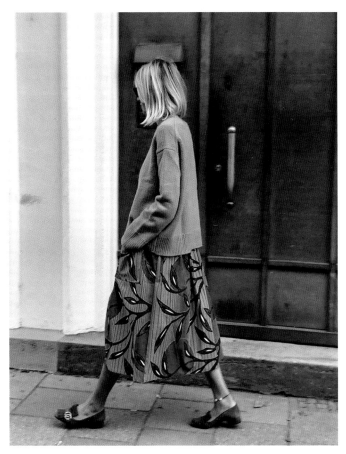

Tina Pahl

CMYK 11/25/36/0
RGB 224/190/162

CMYK 86/49/64/40
RGB 29/78/73

CMYK 22/51/0/0
RGB 205/138/214

CMYK 22/51/0/0
RGB 205/138/214

CMYK 16/18/29/0
RGB 215/201/180

CMYK 79/36/92/28
RGB 54/103/57

CMYK 21/65/79/7
RGB 189/107/70

CMYK 0/27/0/0
RGB 255/201/225

CMYK 4/7/10/0
RGB 244/234/224

CMYK 0/52/67/0
RGB 247/146/94

CMYK 10/28/0/0
RGB 231/189/239

CMYK 43/78/76/61
RGB 79/38/31

CMYK 35/74/56/19
RGB 145/79/85

CMYK 10/28/0/0
RGB 231/189/239

CMYK 0/52/67/0
RGB 247/146/94

CMYK 10/28/42/0
RGB 228/185/149

CMYK 53/100/1/0
RGB 142/30/144

CMYK 4/7/10/0
RGB 244/234/224

CMYK 4/7/10/0
RGB 244/234/224

CMYK 0/25/31/0
RGB 255/200/169

CMYK 21/69/83/7
RGB 188/100/62

CMYK 0/25/31/0
RGB 255/200/169

CMYK 53/100/1/0
RGB 142/30/144

CMYK 0/52/67/0
RGB 247/146/94

CMYK 43/78/76/61
RGB 79/38/31

CMYK 10/28/0/0
RGB 231/189/239

CMYK 35/74/56/19
RGB 145/79/85

CMYK 4/7/10/0
RGB 244/234/224

CMYK 43/78/76/61
RGB 79/38/31

CMYK 21/65/79/7
RGB 189/107/70

CMYK 19/39/0/0
RGB 202/163/207

CMYK 0/27/0/0
RGB 255/201/225

CMYK 4/7/10/0
RGB 244/234/224

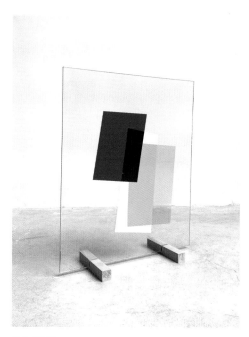

Studio RENS

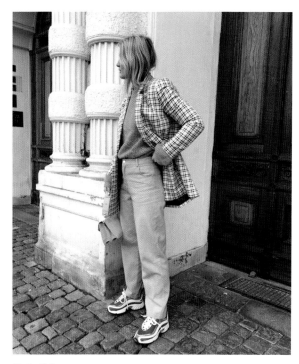

Karoline Dall

W

I

N

T

E

R

CLASSICS

In the winter, we often find ourselves gathering indoors with family and friends for the Holiday season. The holidays bring on traditional colors of berry red, forest green, cobalt blue and gold + silver metallics. We also see a lot of deeper maroon, navy, grey and black. Sky blue and snow white are a big part of the winters palette, however, in general the combinations become much darker (and with more contrast) than the other seasons, emulating the longer, colder winter nights.

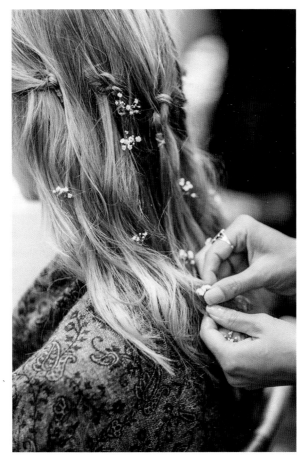

Marchesa FW15 / Photo: Abby Ross

CMYK 77/42/54/19
RGB 62/108/105

CMYK 14/16/24/0
RGB 218/205/188

CMYK 72/52/57/32
RGB 69/86/85

CMYK 2/4/7/0
RGB 247/240/232

CMYK 53/43/74/20
RGB 115/113/79

CMYK 19/44/61/0
RGB 204/148/110

159

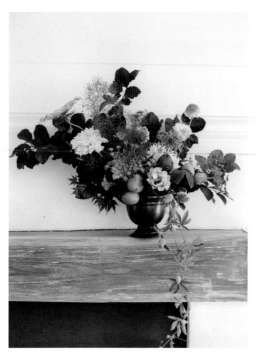

Luisa Brimble

"**Winter** *is not a season, it's a* **celebration**."

-*Anamika Mishra*

Greg Anthony Thomas

CMYK 22/18/65/0
RGB 204/192/118

CMYK 2/4/7/0
RGB 247/240/232

CMYK 36/98/86/57
RGB 93/5/16

CMYK 6/16/5/0
RGB 234/215/221

CMYK 41/30/28/0
RGB 156/163/169

CMYK 75/54/64/46
RGB 52/70/64

CMYK 58/33/53/7
RGB 114/138/122

CMYK 75/54/64/46
RGB 52/70/64

CMYK 07/7/14/0
RGB 235/229/215

CMYK 28/53/75/9
RGB 173/120/78

CMYK 13/10/41/0
RGB 223/215/164

CMYK 75/54/64/46
RGB 52/70/64

CMYK 07/7/14/0
RGB 235/229/215

CMYK 34/77/56/20
RGB 146/75/83

CMYK 55/82/55/56
RGB 73/36/51

CMYK 28/53/75/9
RGB 173/120/78

CMYK 75/54/64/46
RGB 52/70/64

CMYK 39/28/26/0
RGB 161/168/174

CMYK 2/4/7/0
RGB 247/240/232

CMYK 36/98/86/57
RGB 93/5/16

CMYK 5/12/6/0
RGB 238/222/225

CMYK 75/54/64/46
RGB 52/70/64

CMYK 2/4/7/0
RGB 247/240/232

CMYK 22/18/65/0
RGB 204/192/118

CMYK 75/54/64/46
RGB 52/70/64

CMYK 35/38/43/2
RGB 169/151/139

CMYK 5/12/6/0
RGB 238/222/225

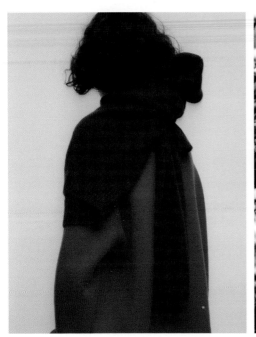

Sophia Aerts

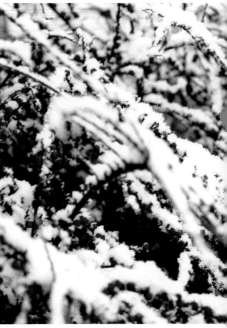

Martin Dawson

CMYK 4/3/2/0
RGB 241/240/242

CMYK 32/90/74/35
RGB 127/42/48

CMYK 40/85/67/50
RGB 98/38/44

CMYK 14/87/100/4
RGB 204/67/29

CMYK 14/87/100/4
RGB 204/67/29

CMYK 4/3/2/0
RGB 241/240/242

CMYK 32/90/74/35
RGB 127/42/48

Arela / Photo: Osma Harvilahti

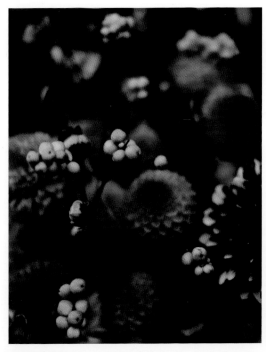

Bows and Lavender

CMYK 7/7/7/0
RGB 235/230/228

CMYK 35/74/75/33
RGB 125/68/55

CMYK 86/51/63/43
RGB 29/73/70

CMYK 13/55/70/1
RGB 217/133/90

CMYK 37/65/70/60
RGB 65/50/42

CMYK 46/20/33/0
RGB 144/175/169

CMYK 22/45/60/2
RGB 197/145/110

CMYK 86/51/63/43
RGB 29/73/70

CMYK 5/5/5/0
RGB 239/235/234

CMYK 46/20/33/0
RGB 144/175/169

CMYK 35/74/75/33
RGB 125/68/55

CMYK 15/90/100/4
RGB 202/60/29

CMYK 7/7/7/0
RGB 235/230/228

CMYK 86/51/63/43
RGB 29/73/70

CMYK 13/55/70/1
RGB 217/133/90

CMYK 13/55/70/1
RGB 217/133/90

CMYK 35/74/75/33
RGB 125/68/55

CMYK 86/51/63/43
RGB 29/73/70

CMYK 8/17/15/0
RGB 230/208/203

CMYK 49/42/69/16
RGB 125/120/88

CMYK 37/65/70/60
RGB 65/50/42

CMYK 7/7/7/0
RGB 235/230/228

CMYK 13/55/70/1
RGB 217/133/90

CMYK 22/45/60/2
RGB 197/145/110

CMYK 86/51/63/43
RGB 29/73/70

CMYK 35/74/75/33
RGB 125/68/55

CMYK 7/7/7/0
RGB 235/230/228

CMYK 80/71/45/35
RGB 56/63/84

CMYK 26/26/12/0
RGB 188/180/197

CMYK 50/44/44/8
RGB 132/127/136

CMYK 21/2/14/0
RGB 200/225/219

CMYK 23/36/59/1
RGB 198/160/117

CMYK 0/16/14/0
RGB 253/218/207

CMYK 0/21/24/0
RGB 252/207/185

CMYK 49/5/7/0
RGB 120/198/225

CMYK 80/71/45/35
RGB 56/63/84

CMYK 80/71/45/35
RGB 56/63/84

CMYK 73/58/9/0
RGB 88/110/168

CMYK 49/5/7/0
RGB 120/198/225

CMYK 28/5/15/0
RGB 182/213/212

CMYK 5/9/3/0
RGB 238/229/234

CMYK 50/44/44/8
RGB 132/127/136

CMYK 7/5/7/0
RGB 234/233/231

CMYK 73/58/9/0
RGB 88/110/168

CMYK 23/36/59/1
RGB 198/160/117

CMYK 0/16/14/0
RGB 253/218/207

CMYK 23/28/42/0
RGB 198/176/149

CMYK 50/44/44/8
RGB 132/127/136

CMYK 9/12/6/0
RGB 227/219/224

CMYK 59/5/0/0
RGB 81/191/237

CMYK 80/71/45/35
RGB 56/63/84

CMYK 73/58/9/0
RGB 88/110/168

CMYK 0/21/24/0
RGB 252/207/185

CMYK 7/5/7/0
RGB 234/233/231

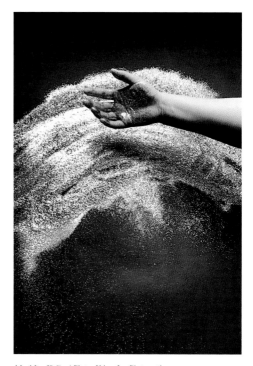

MaeMae & Co / Photo: Kelsey Lee Photography

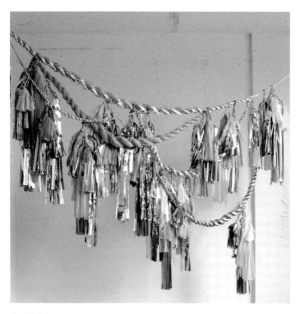

Confetti System

Arianna Lago

CMYK 3/9/11/0
RGB 245/230/220

CMYK 62/69/54/44
RGB 76/60/68

CMYK 36/18/10/0
RGB 162/187/209

CMYK 36/18/10/0
RGB 162/187/209

CMYK 3/9/11/0
RGB 245/230/220

CMYK 38/46/59/9
RGB 154/128/105

CMYK 24/42/61/2
RGB 194/148/110

CMYK 51/70/66/55
RGB 77/51/48

CMYK 11/18/28/0
RGB 224/203/180

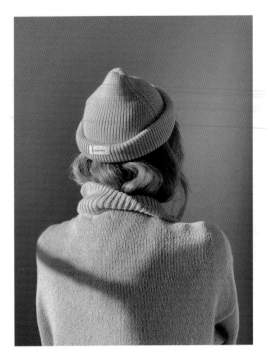

Taylr Anne Castro

Anona Studio

CMYK 43/37/51/5
RGB 149/143/124

CMYK 23/17/22/0
RGB 196/198/192

CMYK 15/18/46/0
RGB 219/200/150

CMYK 30/45/71/6
RGB 175/135/90

CMYK 60/42/56/15
RGB 104/118/106

CMYK 7/7/11/0
RGB 236/229/220

CMYK 7/7/11/0
RGB 236/229/220

CMYK 15/21/60/0
RGB 219/193/125

CMYK 45/42/62/11
RGB 137/128/101

CMYK 35/28/55/1
RGB 171/167/129

CMYK 65/46/64/26
RGB 89/101/85

CMYK 5/16/12/0
RGB 237/213/210

CMYK 9/27/20/0
RGB 228/190/185

CMYK 22/51/70/3
RGB 194/132/91

CMYK 7/7/11/0
RGB 236/229/220

CMYK 36/23/26/0
RGB 166/178/179

CMYK 73/61/63/57
RGB 47/54/43

CMYK 34/31/53/2
RGB 172/162/129

CMYK 7/7/11/0
RGB 236/229/220

CMYK 7/7/11/0
RGB 236/229/220

CMYK 21/46/47/1
RGB 202/146/128

CMYK 15/21/60/0
RGB 219/193/125

CMYK 44/57/89/35
RGB 110/83/43

CMYK 60/42/56/15
RGB 104/118/106

CMYK 18/26/47/0
RGB 211/184/143

CMYK 43/37/51/5
RGB 149/143/124

CMYK 7/7/11/0
RGB 236/229/220

CMYK 7/29/18/0
RGB 232/188/187

CMYK 7/5/7/0
RGB 234/233/231

CMYK 56/39/39/5
RGB 120/135/139

CMYK 24/35/90/2
RGB 195/158/65

CMYK 38/60/100/27
RGB 132/89/20

CMYK 10/17/22/0
RGB 226/206/190

CMYK 42/36/37/1
RGB 153/150/148

CMYK 22/40/31/0
RGB 199/158/158

CMYK 7/5/7/0
RGB 234/233/231

CMYK 7/5/7/0
RGB 234/233/231

CMYK 7/29/18/0
RGB 232/188/187

CMYK 24/35/90/2
RGB 195/158/65

CMYK 24/35/90/2
RGB 195/158/65

CMYK 56/39/39/5
RGB 120/135/139

CMYK 18/13/14/0
RGB 208/208/208

CMYK 38/60/100/27
RGB 132/89/20

CMYK 24/35/90/2
RGB 195/158/65

CMYK 7/5/7/0
RGB 234/233/231

CMYK 10/17/22/0
RGB 226/206/190

CMYK 42/36/37/1
RGB 153/150/148

CMYK 7/29/18/0
RGB 232/188/187

CMYK 62/63/65/54
RGB 65/56/52

CMYK 24/35/90/2
RGB 195/158/65

CMYK 24/35/90/2
RGB 195/158/65

CMYK 7/5/7/0
RGB 234/233/231

CMYK 22/40/31/0
RGB 199/158/158

CMYK 7/29/18/0
RGB 232/188/187

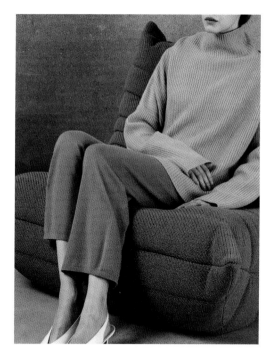

Arela / Photo: Timo Anttonen

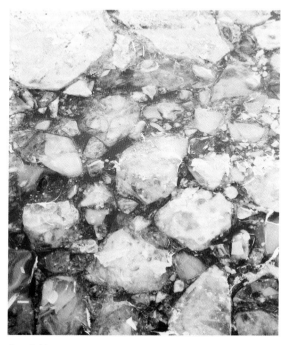

Bryan Rodriguez

MaeMae

CMYK 22/53/76/4
RGB 192/128/80

CMYK 3/20/14/0
RGB 242/208/203

CMYK 3/6/8/0
RGB 245/236/228

CMYK 89/68/42/29
RGB 38/70/94

CMYK 37/24/24/0
RGB 163/175/180

CMYK 73/44/50/18
RGB 75/108/109

CMYK 65/33/0/0
RGB 80/150/229

CMYK 93/88/51/66
RGB 9/17/44

CMYK 1/6/9/0
RGB 250/237/225

CMYK 3/20/14/0
RGB 242/208/203

CMYK 40/41/45/4
RGB 156/140/131

CMYK 1/6/9/0
RGB 250/237/225

CMYK 6/12/16/0
RGB 236/221/238

CMYK 17/51/75/1
RGB 208/137/84

CMYK 93/72/45/37
RGB 28/59/82

CMYK 79/57/43/21
RGB 63/90/107

CMYK 22/53/76/4
RGB 192/128/80

CMYK 4/7/10/0
RGB 242/232/223

CMYK 3/20/14/0
RGB 242/208/203

CMYK 65/33/0/0
RGB 80/150/229

CMYK 80/63/54/46
RGB 45/61/69

CMYK 100/84/31/17
RGB 26/60/109

CMYK 4/7/10/0
RGB 242/232/223

CMYK 73/44/50/18
RGB 75/108/109

CMYK 79/55/63/49
RGB 42/65/62

CMYK 4/7/10/0
RGB 242/232/223

CMYK 30/69/90/22
RGB 150/85/46

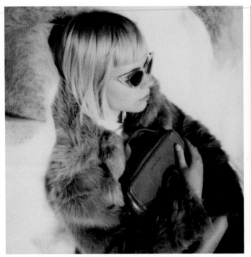

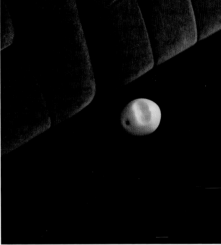

Sofie Sund *Sofie Sund*

CMYK 66/53/69/45
RGB 68/73/60

CMYK 10/7/7/0
RGB 226/226/228

CMYK 47/26/15/0
RGB 140/168/192

CMYK 42/28/14/0
RGB 152/168/192

CMYK 38/63/36/13
RGB 113/95/118

CMYK 10/7/7/0
RGB 226/226/228

CMYK 2/4/7/0
RGB 246/240/231

CMYK 66/53/69/45
RGB 68/73/60

CMYK 13/25/51/0
RGB 221/188/137

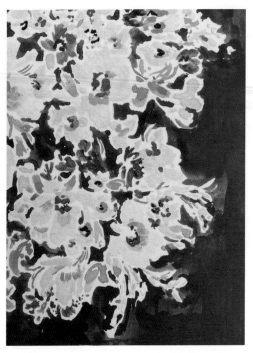

Rose Jocham at Leif Shop

"*In the **depth** of winter I finally learned that there wa in me an invincible **summer**.*"

-*Albert Camus*

Sarita Jaccard for Kamperett / Photo: Maria del Rio

■ CMYK 41/71/78/46
RGB 101/59/43

■ CMYK 14/35/53/0
RGB 218/169/128

CMYK 14/8/18/0
RGB 218/220/206

■ CMYK 72/39/70/23
RGB 72/108/84

■ CMYK 75/35/58/14
RGB 68/122/109

CMYK 9/9/8/0
RGB 229/225/225

■ CMYK 59/31/62/8
RGB 111/140/112

■ CMYK 76/64/63/68
RGB 33/40/41

CMYK 9/9/8/0
RGB 229/225/225

■ CMYK 28/53/75/9
RGB 173/120/78

CMYK 10/12/26/0
RGB 228/215/189

■ CMYK 41/71/78/46
RGB 101/59/43

■ CMYK 35/37/63/4
RGB 168/148/108

CMYK 14/8/18/0
RGB 218/220/206

■ CMYK 72/39/70/23
RGB 72/108/84

■ CMYK 69/47/56/24
RGB 79/100/95

■ CMYK 76/64/63/68
RGB 33/40/41

■ CMYK 36/65/75/27
RGB 133/85/62

CMYK 10/12/26/0
RGB 228/215/189

■ CMYK 34/29/37/0
RGB 173/168/155

■ CMYK 78/46/65/34
RGB 51/87/77

CMYK 5/4/5/0
RGB 240/238/235

■ CMYK 45/26/44/1
RGB 148/165/147

■ CMYK 75/35/58/14
RGB 68/122/109

■ CMYK 81/53/62/44
RGB 41/71/69

■ CMYK 28/53/75/9
RGB 173/120/78

CMYK 9/9/8/0
RGB 229/225/225

W
I
N
T
E
R

NEUTRALS

As the cold weather moves in, we prepare ourselves for hibernation. For many, this can cause a sense of melancholy. The winter, in so many ways, symbolizes an end. For others, winter is a time for peace and reflection, a time to take a pause, get cozy, and plan for the new year ahead. Winter neutrals are strong and minimal—the grey of the bare trees, the white of the snow blanketing the ground, the deep blue and black of the night sky. There is a stillness, a calmness in the air and the neutral colors of winter can be seen in those moments.

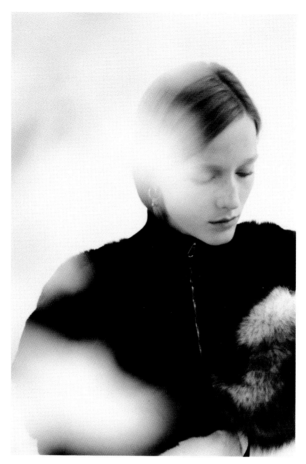

Sophia Aerts

CMYK 20/18/27/0
RGB 206/198/182

CMYK 52/77/75/76
RGB 51/18/10

CMYK 35/47/64/10
RGB 159/126/97

CMYK 20/18/27/0
RGB 206/198/182

CMYK 52/77/75/76
RGB 51/18/10

CMYK 9/6/8/0
RGB 253/233/226

CMYK 4/11/12/0
RGB 240/224/215

CMYK 47/54/79/30
RGB 113/94/61

CMYK 27/30/69/1
RGB 189/167/105

CMYK 15/7/25/0
RGB 216/220/195

CMYK 61/50/49/18
RGB 101/105/107

CMYK 15/11/21/0
RGB 215/213/198

CMYK 20/15/16/0
RGB 203/203/203

CMYK 30/49/99/10
RGB 171/125/46

CMYK 7/3/9/0
RGB 235/238/230

CMYK 43/37/43/3
RGB 151/147/138

CMYK 65/54/95/59
RGB 55/58/22

CMYK 15/7/25/0
RGB 216/220/195

CMYK 7/8/12/0
RGB 235/227/218

CMYK 42/40/74/12
RGB 144/130/185

CMYK 67/66/72/82
RGB 25/20/12

CMYK 30/49/99/10
RGB 171/125/46

CMYK 65/54/95/59
RGB 55/58/22

CMYK 6/7/16/0
RGB 239/230/213

CMYK 23/24/36/0
RGB 199/184/161

CMYK 4/11/12/0
RGB 240/224/215

CMYK 42/40/74/12
RGB 144/130/185

CMYK 43/37/43/3
RGB 151/147/138

CMYK 47/52/79/30
RGB 113/94/61

CMYK 42/40/74/12
RGB 144/130/185

CMYK 27/30/69/1
RGB 189/167/105

CMYK 23/24/36/0
RGB 199/184/161

CMYK 6/7/16/0
RGB 239/230/213

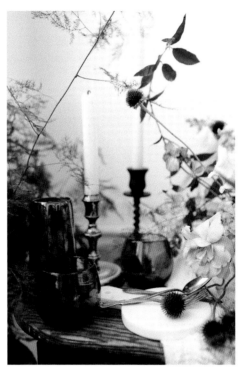

Photo: Peyton Curry / Florals: Vessel & Stem / Styling & Design: Sabrina Allison Design

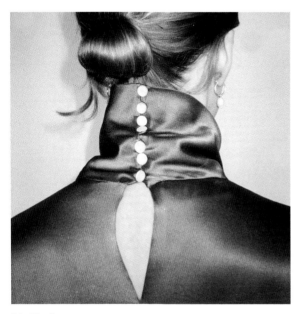

I Am That Shop

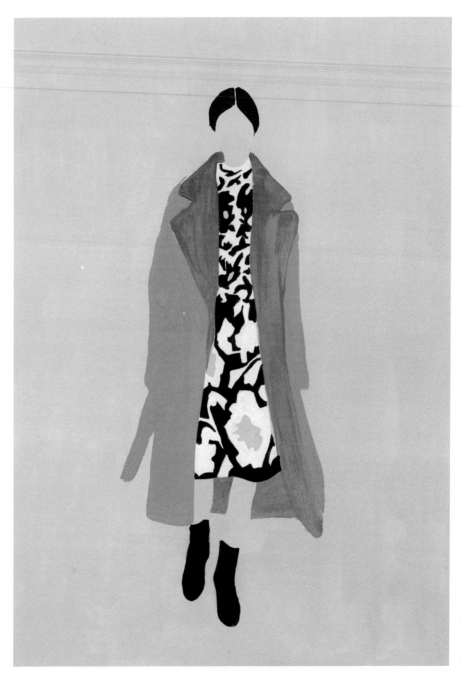

Megan Galante

CMYK 100/93/30/19
RGB 25/45/105

CMYK 3/4/4/0
RGB 245/240/237

CMYK 19/46/84/2
RGB 203/143/70

CMYK 7/12/18/0
RGB 236/220/204

CMYK 3/4/4/0
RGB 245/240/237

CMYK 49/67/74/54
RGB 81/55/42

CMYK 19/46/84/2
RGB 203/143/70

CMYK 7/12/18/0
RGB 236/220/204

CMYK 96/87/21/8
RGB 46/63/125

CMYK 7/12/18/0
RGB 236/220/204

CMYK 19/46/84/2
RGB 203/143/70

CMYK 49/67/74/54
RGB 81/55/42

CMYK 96/87/21/8
RGB 46/63/125

CMYK 7/12/18/0
RGB 236/220/204

CMYK 30/53/94/12
RGB 168/117/52

CMYK 100/93/30/19
RGB 25/45/105

CMYK 30/53/94/12
RGB 168/117/52

CMYK 3/4/4/0
RGB 245/240/237

CMYK 14/30/54/0
RGB 217/178/129

CMYK 30/53/94/12
RGB 168/117/52

CMYK 100/93/30/19
RGB 25/45/105

CMYK 7/12/18/0
RGB 236/220/204

CMYK 3/4/4/0
RGB 245/240/237

CMYK 3/4/4/0
RGB 245/240/237

CMYK 7/12/18/0
RGB 236/220/204

CMYK 49/67/74/54
RGB 81/55/42

CMYK 30/53/94/12
RGB 168/117/52

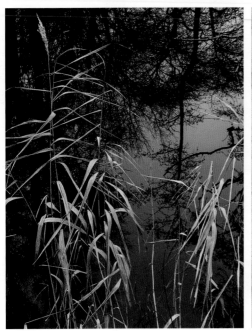

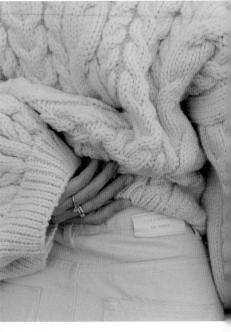

Janneke Luursema

Taylr Anne Castro

CMYK 4/6/9/0
RGB 243/235/226

CMYK 76/59/54/38
RGB 58/73/79

CMYK 23/28/31/0
RGB 198/178/167

CMYK 22/34/50/0
RGB 200/165/132

CMYK 3/7/69/0
RGB 250/226/110

CMYK 4/6/9/0
RGB 243/235/226

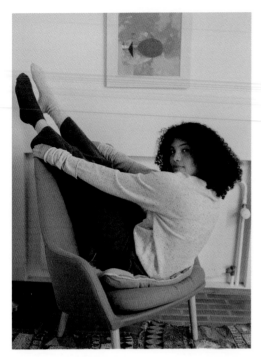

Arela / Photo: Emma Sarpaniemi

Winter is time for
peace and reflection.

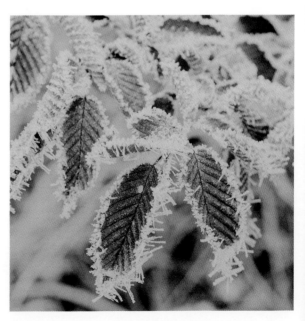

Sandra Frey

CMYK 33/23/28//0
RGB 173/180/176

CMYK 37/66/80/31
RGB 127/80/54

CMYK 14/13/12/0
RGB 217/213/213

CMYK 18/61/67/3
RGB 201/120/92

CMYK 21/21/39/0
RGB 204/190/159

CMYK 62/53/68/39
RGB 80/80/66

CMYK 32/55/71/13
RGB 161/113/82

CMYK 7/6/4/0
RGB 233/235/233

CMYK 35/19/23/0
RGB 167/185/187

CMYK 32/21/14/0
RGB 173/185/199

CMYK 65/66/74/83
RGB 25/17/5

CMYK 27/43/65/3
RGB 183/143/103

CMYK 8/7/6/0
RGB 230/228/229

CMYK 27/70/98/18
RGB 161/88/40

CMYK 40/17/20/0
RGB 155/185/193

CMYK 28/70/84/18
RGB 159/88/55

CMYK 61/31/33/1
RGB 108/148/158

CMYK 82/52/58/36
RGB 43/80/80

CMYK 8/6/6/0
RGB 231/230/230

CMYK 9/9/17/0
RGB 230/223/208

CMYK 37/77/94/47
RGB 105/51/24

CMYK 33/23/28//0
RGB 173/180/176

CMYK 47/44/58/13
RGB 133/122/104

CMYK 65/66/74/83
RGB 25/17/5

CMYK 62/53/68/39
RGB 80/80/66

CMYK 8/6/6/0
RGB 231/230/230

CMYK 35/19/23/0
RGB 167/185/187

CMYK 51/47/76/26
RGB 111/103/71

CMYK 21/31/73/0
RGB 203/168/97

CMYK 5/5/7/0
RGB 239/235/230

CMYK 12/11/14//0
RGB 222/217/211

CMYK 7/13/18/0
RGB 235/218/202

CMYK 42/51/77/22
RGB 132/105/70

CMYK 44/57/88/34
RGB 113/85/45

CMYK 13/24/34/0
RGB 220/190/165

CMYK 51/47/76/26
RGB 111/103/71

CMYK 5/5/7/0
RGB 239/235/230

CMYK 69/61/62/53
RGB 56/58/57

CMYK 10/8/7/0
RGB 225/225/227

CMYK 21/31/73/0
RGB 203/168/97

CMYK 51/47/76/26
RGB 111/103/71

CMYK 10/19/26/0
RGB 227/202/182

CMYK 69/61/62/53
RGB 56/58/57

CMYK 5/5/7/0
RGB 239/235/230

CMYK 51/47/76/26
RGB 111/103/71

CMYK 51/47/76/26
RGB 111/103/71

CMYK 13/24/34/0
RGB 220/190/165

CMYK 69/61/62/53
RGB 56/58/57

CMYK 11/9/8/0
RGB 223/223/225

CMYK 42/51/77/22
RGB 132/105/70

CMYK 13/24/34/0
RGB 220/190/165

CMYK 5/5/7/0
RGB 239/235/230

CMYK 21/31/73/0
RGB 203/168/97

CMYK 44/57/88/34
RGB 113/85/45

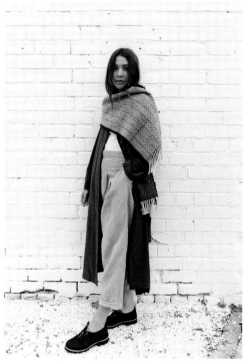

1 Cascales Alimbau

Botanical Inks / Photo: Kasia Kiliszek

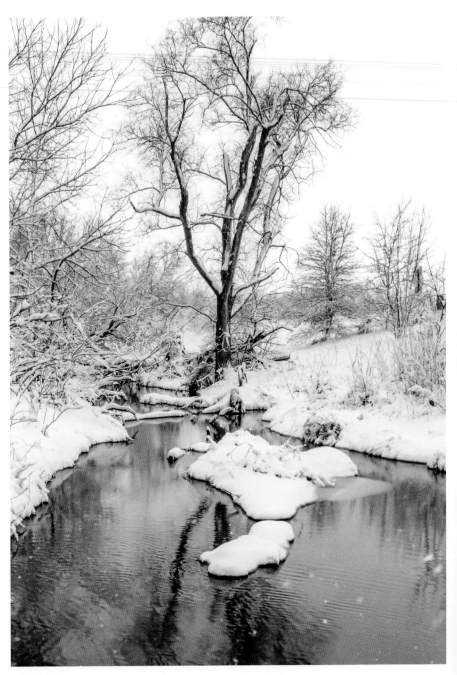

Jeffrey Hamilton

CMYK 9/6/8/0
RGB 230/230/228

CMYK 46/33/41/1
RGB 145/153/146

CMYK 52/53/67/29
RGB 106/93/76

CMYK 20/21/25/0
RGB 205/193/183

CMYK 41/27/37/0
RGB 168/158/168

CMYK 58/57/52/25
RGB 101/92/93

CMYK 31/43/61/5
RGB 175/140/107

CMYK 40/27/37/0
RGB 159/168/158

CMYK 9/6/8/0
RGB 230/230/228

CMYK 28/23/29/0
RGB 187/183/174

CMYK 59/59/69/49
RGB 73/65/54

CMYK 9/6/8/0
RGB 230/230/228

CMYK 9/6/8/0
RGB 230/230/228

CMYK 56/51/65/28
RGB 101/95/79

CMYK 41/27/37/0
RGB 168/158/168

CMYK 9/6/8/0
RGB 230/230/228

CMYK 20/21/25/0
RGB 205/193/183

CMYK 58/57/52/25
RGB 101/92/93

CMYK 40/27/37/0
RGB 159/168/158

CMYK 58/57/52/25
RGB 101/92/93

CMYK 9/6/8/0
RGB 230/230/228

CMYK 28/23/29/0
RGB 187/183/174

CMYK 57/44/57/16
RGB 110/115/103

CMYK 31/43/61/5
RGB 175/140/107

CMYK 56/51/65/28
RGB 101/95/79

CMYK 9/6/8/0
RGB 230/230/228

CMYK 46/33/41/1
RGB 145/153/146

CMYK 6/4/6/0
RGB 238/237/233

CMYK 38/24/24/0
RGB 162/175/181

CMYK 25/29/55/1
RGB 193/155/121

CMYK 16/7/5/0
RGB 210/223/232

CMYK 63/51/40/11
RGB 103/111/124

CMYK 7/15/17/0
RGB 234/215/205

CMYK 47/38/36/2
RGB 142/143/147

CMYK 6/4/6/0
RGB 238/237/233

CMYK 7/15/17/0
RGB 234/215/205

CMYK 6/4/6/0
RGB 238/237/233

CMYK 31/24/28/0
RGB 180/179/174

CMYK 63/51/40/11
RGB 103/111/124

CMYK 16/7/5/0
RGB 210/223/232

CMYK 6/4/6/0
RGB 238/237/233

CMYK 25/29/55/1
RGB 193/155/121

CMYK 25/29/55/1
RGB 193/155/121

CMYK 63/51/40/11
RGB 103/111/124

CMYK 6/4/6/0
RGB 238/237/233

CMYK 7/15/17/0
RGB 234/215/205

CMYK 47/38/36/2
RGB 142/143/147

CMYK 16/7/5/0
RGB 210/223/232

CMYK 38/24/24/0
RGB 162/175/181

CMYK 6/4/6/0
RGB 238/237/233

CMYK 7/15/17/0
RGB 234/215/205

CMYK 71/58/56/37
RGB 68/76/78

CMYK 24/17/6/0
RGB 192/199/218

CMYK 6/4/6/0
RGB 238/237/233

Bryony Gibbs

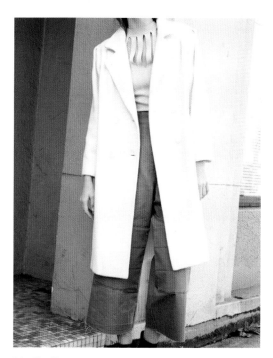

I Am That Shop

CMYK 14/11/10/0
RGB 215/216/218

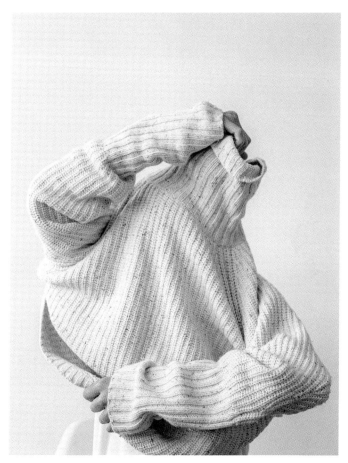

Mukuko Studio

CMYK 7/11/12/0
RGB 249/118/95

CMYK 45/41/46/6
RGB 143/136/128

CMYK 18/11/11/0
RGB 207/212/215

CMYK 6/4/2/0
RGB 236/238/242

CMYK 7/5/6/0
RGB 233/233/232

CMYK 26/24/24/0
RGB 190/183/181

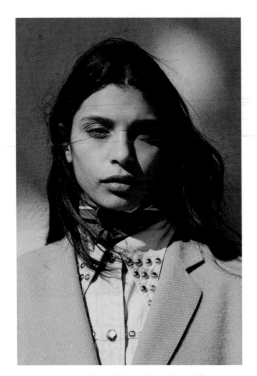

Lilly Reilly (Scout) for Freda Salvador / Photo: María del Río

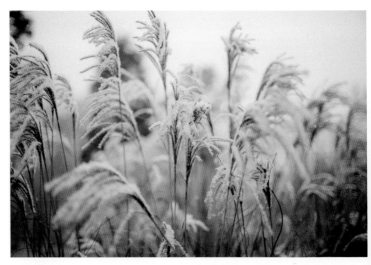

Nani Williams

CMYK 27/20/24/0
RGB 188/190/185

CMYK 7/5/8/0
RGB 234/233/228

CMYK 24/53/72/6
RGB 185/125/85

CMYK 18/8/12/0
RGB 208/217/216

CMYK 7/5/8/0
RGB 234/233/228

CMYK 50/37/42/4
RGB 135/141/137

CMYK 15/24/40/0
RGB 217/190/156

CMYK 18/8/12/0
RGB 208/217/216

CMYK 41/48/61/13
RGB 145/120/98

CMYK 16/13/16/0
RGB 213/210/205

CMYK 50/37/42/4
RGB 135/141/137

CMYK 64/54/65/39
RGB 76/79/69

CMYK 58/48/54/19
RGB 106/107/101

CMYK 7/5/8/0
RGB 234/233/228

CMYK 24/53/72/6
RGB 185/125/85

CMYK 58/48/54/19
RGB 106/107/101

CMYK 7/5/8/0
RGB 234/233/228

CMYK 24/53/72/6
RGB 185/125/85

CMYK 18/8/12/0
RGB 208/217/216

CMYK 7/5/8/0
RGB 234/233/228

CMYK 18/8/12/0
RGB 208/217/216

CMYK 15/24/40/0
RGB 217/190/156

CMYK 64/54/65/39
RGB 76/79/69

CMYK 64/54/65/39
RGB 76/79/69

CMYK 15/24/40/0
RGB 217/190/156

CMYK 7/5/8/0
RGB 234/233/228

CMYK 41/48/61/13
RGB 145/120/98

■ CMYK 12/15/15/0
RGB 221/210/206

■ CMYK 92/63/41/24
RGB 25/79/103

■ CMYK 17/26/30/0
RGB 211/185/170

■ CMYK 72/44/42/11
RGB 80/116/125

□ CMYK 13/3/2/0
RGB 219/234/242

■ CMYK 61/66/68/68
RGB 51/40/36

■ CMYK 93/81/52/66
RGB 10/24/45

□ CMYK 26/14/13/0
RGB 188/201/209

□ CMYK 5/6/6/0
RGB 240/234/231

□ CMYK 5/6/6/0
RGB 240/234/231

■ CMYK 33/48/67/10
RGB 162/125/92

■ CMYK 72/44/42/11
RGB 80/116/125

□ CMYK 17/4/7/0
RGB 209/227/230

■ CMYK 93/81/52/66
RGB 10/24/45

■ CMYK 31/22/27/0
RGB 178/182/178

□ CMYK 7/3/6/0
RGB 234/237/234

■ CMYK 93/81/52/66
RGB 10/24/45

■ CMYK 17/26/30/0
RGB 211/185/170

■ CMYK 81/51/38/13
RGB 59/104/125

□ CMYK 18/9/14/0
RGB 207/215/212

■ CMYK 61/66/68/68
RGB 51/40/36

■ CMYK 27/38/56/1
RGB 188/155/121

■ CMYK 92/63/41/24
RGB 25/79/103

□ CMYK 34/18/16/0
RGB 168/187/199

■ CMYK 76/68/64/82
RGB 13/15/18

□ CMYK 7/3/6/0
RGB 234/237/234

■ CMYK 94/65/40/24
RGB 21/76/103

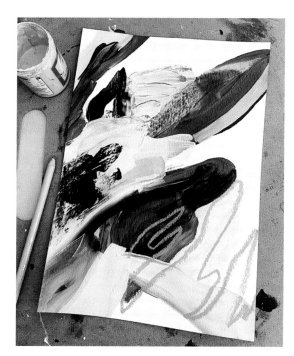

Rose Eads Design

Métaformose

W
I
N
T
E
R

B O L D S

Winter is the most dramatic season, and its bright, stark colors reflect the drama in its palette. Deep reds, rich teals, majestic purples, frozen blues—winter bolds are powerful and intense. Winter can sometimes be referred to as the jewel-toned (tones that are derived from gemstones) season, because it relates to so many rich and saturated colors. Jewel tones are energetic and eye-catching, they are sure to make a statement, and imitate the strength of the winter season.

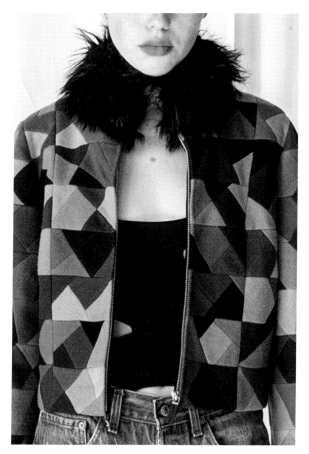

I Am That Shop

CMYK 13/77/96/2
RGB 210/91/44

CMYK 42/29/100/5
RGB 156/153/43

CMYK 13/48/64/0
RGB 219/146/103

CMYK 6/19/28/0
RGB 237/205/179

CMYK 69/56/66/51
RGB 57/63/56

CMYK 39/70/72/37
RGB 114/68/55

Aliya Wanek

Studio RENS in collaboration with Tarkett (DESSO)

■ **CMYK** 42/86/45/23
RGB 130/56/86

■ **CMYK** 67/14/33/0
RGB 80/170/173

■ **CMYK** 69/62/61/52
RGB 58/58/58

■ **CMYK** 11/45/3/0
RGB 217/155/91

■ **CMYK** 67/14/33/0
RGB 80/170/173

■ **CMYK** 67/84/42/35
RGB 82/49/80

■ **CMYK** 67/59/28/6
RGB 101/105/138

■ **CMYK** 69/62/61/52
RGB 58/58/58

■ **CMYK** 67/14/33/0
RGB 80/170/173

■ **CMYK** 16/13/14/0
RGB 211/210/208

■ **CMYK** 76/39/41/8
RGB 68/123/133

■ **CMYK** 51/82/41/23
RGB 117/62/93

■ **CMYK** 33/82/39/7
RGB 165/76/108

■ **CMYK** 62/83/47/44
RGB 79/44/68

■ **CMYK** 67/14/33/0
RGB 80/170/173

■ **CMYK** 69/62/61/52
RGB 58/58/58

■ **CMYK** 33/82/39/7
RGB 165/76/108

■ **CMYK** 67/14/33/0
RGB 80/170/173

■ **CMYK** 16/13/14/0
RGB 211/210/208

■ **CMYK** 76/39/41/8
RGB 68/123/133

■ **CMYK** 67/14/33/0
RGB 80/170/173

■ **CMYK** 16/13/14/0
RGB 211/210/208

■ **CMYK** 42/86/45/23
RGB 130/56/86

■ **CMYK** 62/83/47/44
RGB 79/44/68

■ **CMYK** 16/13/14/0
RGB 211/210/208

■ **CMYK** 11/45/3/0
RGB 217/155/91

■ **CMYK** 67/14/33/0
RGB 80/170/173

CMYK 87/42/52/19
RGB 28/106/108

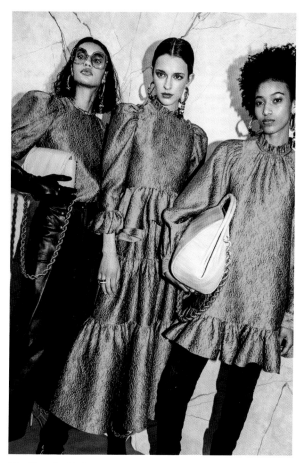

Nina Westervelt / Ulla Johnson FW20

CMYK 77/69/62/77
RGB 20/23/28

CMYK 63/0/31/0
RGB 58/204/195

CMYK 7/19/11/0
RGB 232/206/207

CMYK 93/65/43/28
RGB 22/73/96

CMYK 87/42/52/19
RGB 28/106/108

CMYK 2/14/68/0
RGB 251/215/110

■ CMYK 89/77/23/7
RGB 57/77/130

■ CMYK 0/55/96/0
RGB 251/140/33

□ CMYK 6/5/6/0
RGB 236/235/233

■ CMYK 37/96/71/54
RGB 95/18/35

■ CMYK 52/13/26/0
RGB 123/181/185

■ CMYK 94/89/47/59
RGB 18/23/53

■ CMYK 94/89/47/59
RGB 18/23/53

■ CMYK 0/64/100/0
RGB 245/122/19

□ CMYK 6/5/6/0
RGB 236/235/233

■ CMYK 11/31/79/0
RGB 226/175/82

■ CMYK 92/84/48/57
RGB 24/30/56

■ CMYK 94/67/5/0
RGB 10/94/164

■ CMYK 37/96/71/54
RGB 95/18/35

■ CMYK 52/13/26/0
RGB 123/181/185

□ CMYK 6/5/6/0
RGB 236/235/233

■ CMYK 52/13/26/0
RGB 123/181/185

■ CMYK 5/16/30/0
RGB 240/213/179

■ CMYK 37/96/71/54
RGB 95/18/35

□ CMYK 6/5/6/0
RGB 236/235/233

■ CMYK 8/66/92/0
RGB 226/117/52

■ CMYK 37/96/71/54
RGB 95/18/35

■ CMYK 5/16/30/0
RGB 240/213/179

■ CMYK 52/13/26/0
RGB 123/181/185

□ CMYK 6/5/6/0
RGB 236/235/233

■ CMYK 11/31/79/0
RGB 226/175/82

■ CMYK 96/70/5/0
RGB 10/90/161

■ CMYK 94/89/47/59
RGB 18/23/53

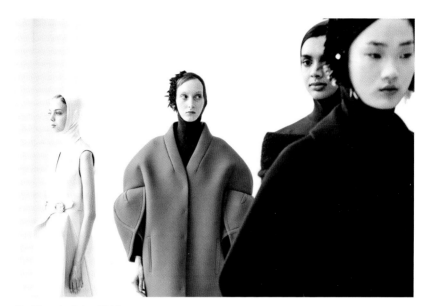

Nina Westervelt / Delpozo FW17

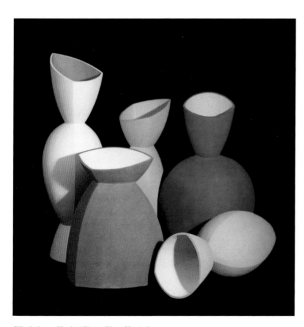

Elisabeth von Krogh / Photo: Bjorn Harstad

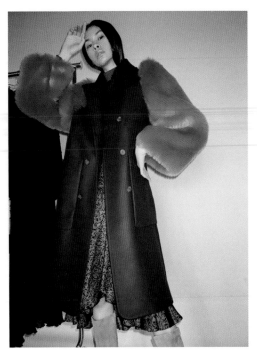

Rodebjer Coat by Bona Drag / Photo: Heather Wojner

*"I found I could say things with **color** and **shapes** that I couldn't say any other way."*

-Georgia O'Keefe

Alice Allum Design

CMYK 6/65/87/0
RGB 231/119/60

CMYK 1/18/2/0
RGB 249/215/226

CMYK 70/45/65/28
RGB 75/98/84

CMYK 2/18/26/0
RGB 248/213/186

CMYK 12/9/10/0
RGB 220/220/220

CMYK 75/68/65/82
RGB 15/16/18

CMYK 76/35/50/10
RGB 64/125/122

CMYK 12/9/10/0
RGB 220/220/220

CMYK 7/67/73/0
RGB 227/115/81

CMYK 2/18/26/0
RGB 248/213/186

CMYK 1/62/82/0
RGB 242/127/67

CMYK 16/60/77/2
RGB 206/122/77

CMYK 2/18/3/0
RGB 244/214/225

CMYK 4/63/87/0
RGB 234/123/59

CMYK 76/35/50/10
RGB 64/125/122

CMYK 70/45/65/28
RGB 75/98/84

CMYK 0/15/0/0
RGB 254/223/235

CMYK 2/18/26/0
RGB 248/213/186

CMYK 6/65/87/0
RGB 231/119/60

CMYK 2/18/3/0
RGB 244/214/225

CMYK 75/68/65/82
RGB 15/16/18

CMYK 12/9/10/0
RGB 220/220/220

CMYK 6/65/87/0
RGB 231/119/60

CMYK 6/65/87/0
RGB 231/119/60

CMYK 0/15/0/0
RGB 254/223/235

CMYK 75/68/65/82
RGB 15/16/18

CMYK 2/18/26/0
RGB 248/213/186

CMYK 69/67/61/64
RGB 46/42/45

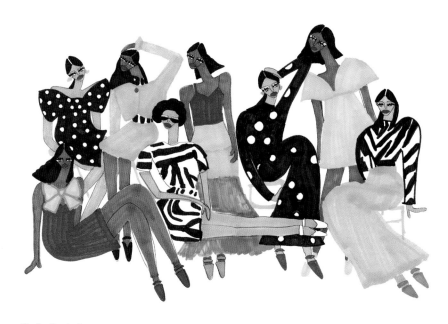

Karolina Pawelczyk

CMYK 15/94/84/4
RGB 200/49/56

CMYK 0/29/8/0
RGB 251/195/203

CMYK 54/28/100/7
RGB 128/146/58

CMYK 39/6/0/0
RGB 146/205/140

CMYK 69/67/61/64
RGB 46/42/45

CMYK 5/77/6/0
RGB 228/96/155

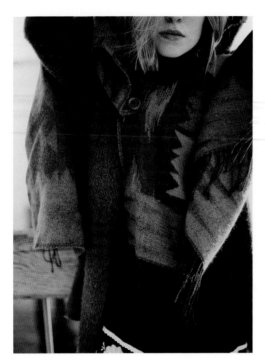

Eli Defaria

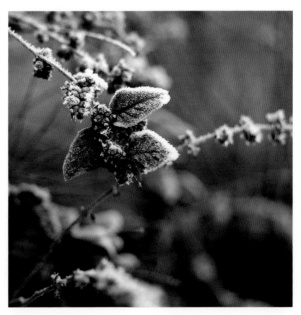

Freestocks

CMYK 31/98/20/1
RGB 177/38/121

CMYK 8/7/1/0/0
RGB 231/228/223

CMYK 29/45/36/1
RGB 185/160/137

CMYK 78/74/48/45
RGB 53/52/70

CMYK 78/70/45/34
RGB 60/65/85

CMYK 12/84/81/2
RGB 210/75/62

CMYK 43/9/32/0
RGB 149/194/180

CMYK 73/64/41/22
RGB 78/83/104

CMYK 31/98/20/1
RGB 177/38/121

CMYK 27/77/62/13
RGB 167/81/82

CMYK 43/9/32/0
RGB 149/194/180

CMYK 8/7/1/0/0
RGB 231/228/223

CMYK 31/98/20/1
RGB 177/38/121

CMYK 12/84/81/2
RGB 210/75/62

CMYK 28/31/0/0
RGB 181/172/221

CMYK 31/98/20/1
RGB 177/38/121

CMYK 49/74/61/49
RGB 88/52/56

CMYK 3/3/9/0
RGB 245/241/230

CMYK 12/84/81/2
RGB 210/75/62

CMYK 78/70/45/34
RGB 60/65/85

CMYK 43/9/32/0
RGB 149/194/180

CMYK 29/45/36/1
RGB 185/160/137

CMYK 8/7/1/0/0
RGB 231/228/223

CMYK 43/9/32/0
RGB 149/194/180

CMYK 8/7/1/0/0
RGB 231/228/223

CMYK 31/98/20/1
RGB 177/38/121

CMYK 78/74/48/45
RGB 53/52/70

Ana de Cova. Somewhere, 2019. Courtesy of the artist

Winter is the most **dramatic** *season.*

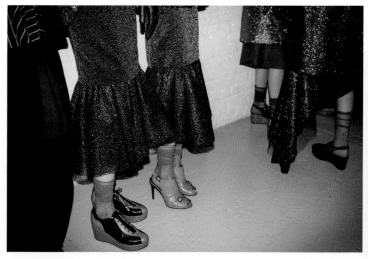

Nina Westervelt / Rodarte FW14

CMYK 73/10/50/0
RGB 59/170/150

CMYK 9/9/15/0
RGB 231/223/211

CMYK 36/24/71/1
RGB 171/170/106

CMYK 67/71/63/83
RGB 23/8/13

CMYK 44/98/0/0
RGB 160/24/153

CMYK 77/13/24/0
RGB 2/167/187

CMYK 46/80/41/18
RGB 130/70/98

CMYK 67/71/63/83
RGB 23/8/13

CMYK 9/9/15/0
RGB 231/223/211

CMYK 26/26/24/0
RGB 190/180/180

CMYK 43/69/81/49
RGB 93/58/38

CMYK 65/9/0/0
RGB 43/182/239

CMYK 27/35/69/2
RGB 188/158/102

CMYK 85/30/66/13
RGB 26/124/104

CMYK 67/71/63/83
RGB 23/8/13

CMYK 65/9/0/0
RGB 43/182/239

CMYK 9/9/15/0
RGB 231/223/211

CMYK 46/80/41/18
RGB 130/70/98

CMYK 33/85/0/0
RGB 182/67/168

CMYK 27/35/69/2
RGB 188/158/102

CMYK 43/69/81/49
RGB 93/58/38

CMYK 9/9/15/0
RGB 231/223/211

CMYK 85/30/66/13
RGB 26/124/104

CMYK 77/13/24/0
RGB 2/167/187

CMYK 85/30/66/13
RGB 26/124/104

CMYK 26/26/24/0
RGB 190/180/180

CMYK 9/9/15/0
RGB 231/223/211

Marie Bernard

CMYK 10/79/1/0
RGB 218/91/160

CMYK 73/67/63/71
RGB 35/35/37

CMYK 7/5/15/0
RGB 235/232/215

CMYK 7/5/15/0
RGB 235/232/215

CMYK 10/79/1/0
RGB 218/91/160

CMYK 20/48/79/3
RGB 200/138/78

CMYK 20/48/79/3
RGB 200/138/78

CMYK 73/67/63/71
RGB 35/35/37

CMYK 10/79/1/0
RGB 218/91/160

CMYK 10/79/1/0
RGB 218/91/160

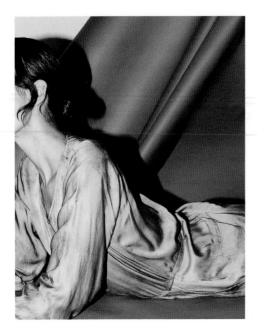

Frances May / Photo: Anna Greer

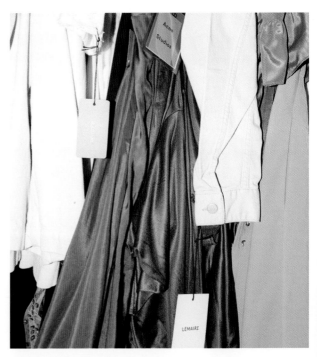

Frances May / Photo: Anna Greer

CMYK 28/71/81/19
RGB 157/85/58

CMYK 25/0/11/0
RGB 188/232/230

CMYK 9/16/0/0
RGB 227/214/253

CMYK 85/41/58/22
RGB 35/103/98

CMYK 4/5/9/0
RGB 242/237/227

CMYK 67/40/0/0
RGB 74/142/236

CMYK 3/36/74/0
RGB 242/172/90

CMYK 32/77/69/25
RGB 142/71/66

CMYK 10/0/11/0
RGB 227/243/229

CMYK 74/64/60/60
RGB 42/47/50

CMYK 83/27/54/6
RGB 29/136/126

CMYK 9/16/0/0
RGB 227/214/253

CMYK 82/45/52/22
RGB 50/100/102

CMYK 36/1/17/0
RGB 161/214/213

CMYK 16/58/68/2
RGB 206/125/92

CMYK 4/5/9/0
RGB 242/237/227

CMYK 28/71/81/19
RGB 157/85/58

CMYK 36/1/17/0
RGB 161/214/213

CMYK 85/41/58/22
RGB 35/103/98

CMYK 85/41/58/22
RGB 35/103/98

CMYK 25/0/11/0
RGB 188/232/230

CMYK 74/64/60/60
RGB 42/47/50

CMYK 67/40/0/0
RGB 74/142/236

CMYK 9/16/0/0
RGB 227/214/253

CMYK 82/45/52/22
RGB 50/100/102

CMYK 28/78/68/16
RGB 162/77/73

CMYK 43/76/68/49
RGB 93/50/48

■ CMYK 64/37/36/4
RGB 101/135/145

CMYK 34/0/7/0
RGB 153/235/246

CMYK 4/17/3/0
RGB 240/214/225

■ CMYK 74/63/53/43
RGB 59/62/72

■ CMYK 74/17/39/0
RGB 58/162/161

CMYK 8/7/5/0
RGB 231/230/233

CMYK 13/25/43/0
RGB 223/190/150

■ CMYK 70/47/45/16
RGB 84/108/115

CMYK 9/0/38/0
RGB 234/247/175

■ CMYK 53/78/60/62
RGB 68/35/43

CMYK 4/9/11/0
RGB 240/228/220

■ CMYK 34/69/30/2
RGB 170/102/131

■ CMYK 91/58/48/30
RGB 21/78/93

CMYK 4/17/3/0
RGB 240/214/225

CMYK 34/0/7/0
RGB 153/235/246

CMYK 34/0/7/0
RGB 153/235/246

CMYK 8/7/5/0
RGB 231/230/233

■ CMYK 70/47/45/16
RGB 84/108/115

■ CMYK 53/78/60/62
RGB 68/35/43

■ CMYK 82/32/34/3
RGB 31/136/153

CMYK 13/25/43/0
RGB 223/190/150

CMYK 9/0/38/0
RGB 234/247/175

■ CMYK 79/74/53/58
RGB 41/40/54

CMYK 4/17/3/0
RGB 240/214/225

■ CMYK 79/74/53/58
RGB 41/40/54

CMYK 19/20/24/0
RGB 207/195/186

■ CMYK 83/38/28/2
RGB 34/129/157

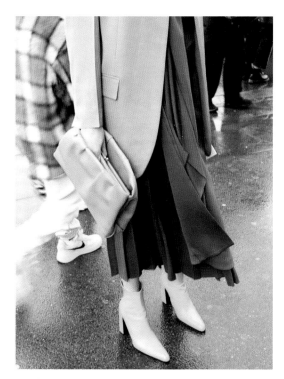

Anna Ovtchinnikova

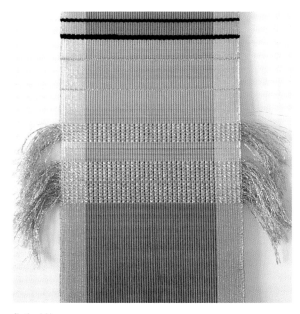

Justine Ashbee

CLASSICS

Ah, spring. A fresh start, a new beginning, a rebirth. The days become longer and brighter once again and nature rejuvenates as the flowers begin to bloom, plants and grass come back to life, and green is popping up everywhere. Spring is full of hope, happiness and optimism. The mood lifts in spring, and creativity is found in new projects. Colors are light and bright meeting the positive energy that spring brings. Along with green we observe pastels, rainbow, turquoise, yellow and pink.

& Other Stories

CMYK 21/0/16/0
RGB 199/230/219

CMYK 29/0/9/0
RGB 177/224/230

CMYK 3/1/24/0
RGB 247/243/203

CMYK 3/1/24/0
RGB 247/243/203

CMYK 3/7/69/0
RGB 192/227/233

CMYK 5/20/34/0
RGB 240/205/168

CMYK 0/21/2/0
RGB 249/210/223

CMYK 20/36/0/0
RGB 200/168/215

CMYK 1/3/11/0
RGB 252/243/226

CMYK 0/35/53/0
RGB 255/180/126

CMYK 7/18/0/0
RGB 234/210/247

CMYK 42/0/59/0
RGB 153/210/141

CMYK 1/3/11/0
RGB 252/243/226

CMYK 7/18/0/0
RGB 234/210/247

CMYK 0/35/53/0
RGB 255/180/126

CMYK 42/0/59/0
RGB 153/210/141

CMYK 0/35/53/0
RGB 255/180/126

CMYK 1/3/11/0
RGB 252/243/226

CMYK 13/32/5/0
RGB 217/178/202

CMYK 1/3/11/0
RGB 252/243/226

CMYK 2/26/4/0
RGB 242/198/214

CMYK 7/18/0/0
RGB 234/210/247

CMYK 1/3/11/0
RGB 252/243/226

CMYK 0/21/2/0
RGB 249/210/223

CMYK 42/0/59/0
RGB 153/210/141

CMYK 0/21/2/0
RGB 249/210/223

CMYK 1/3/11/0
RGB 252/243/226

CMYK 7/18/0/0
RGB 234/210/247

CMYK 0/35/53/0
RGB 255/180/126

CMYK 7/5/5/0
RGB 233/233/233

CMYK 13/32/5/0
RGB 217/178/202

CMYK 1/3/11/0
RGB 252/243/226

CMYK 10/16/36/0
RGB 229/208/169

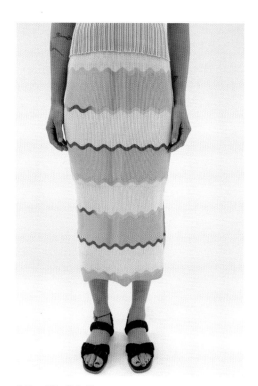

Beklina / Skirt: Julia Heuer

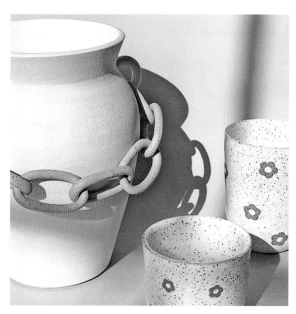

Mimi Ceramics

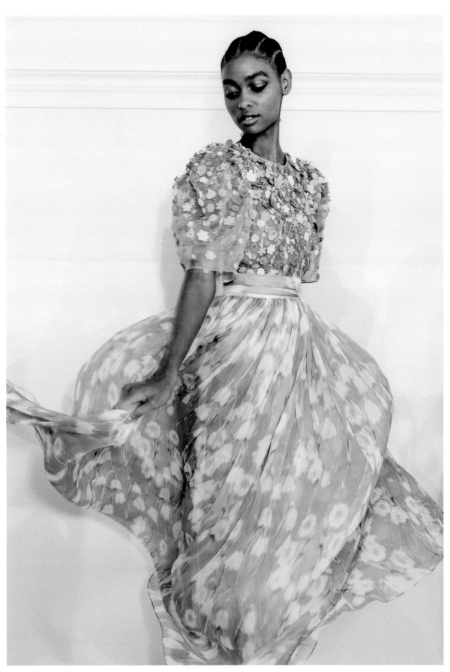

Nina Westervelt / Carolina Herrera SS20

CMYK 21/22/59/0
RGB 205/187/127

CMYK 20/4/34/0
RGB 207/220/180

CMYK 14/7/2/0
RGB 214/223/237

CMYK 42/20/3/0
RGB 145/180/217

CMYK 57/4/43/0
RGB 109/190/165

CMYK 3/20/18/0
RGB 243/208/196

CMYK 5/6/28/0
RGB 242/231/191

CMYK 21/22/59/0
RGB 205/187/127

CMYK 20/9/1/0
RGB 198/214/236

CMYK 25/11/4/0
RGB 188/208/227

CMYK 58/14/46/0
RGB 114/175/154

CMYK 5/6/28/0
RGB 242/231/191

CMYK 3/2/2/0
RGB 243/243/245

CMYK 20/5/35/0
RGB 207/218/178

CMYK 44/19/0/0
RGB 139/181/228

CMYK 3/2/2/0
RGB 243/243/245

CMYK 29/6/47/0
RGB 185/208/156

CMYK 42/20/3/0
RGB 145/180/217

CMYK 14/7/2/0
RGB 214/223/237

CMYK 20/5/35/0
RGB 207/218/178

CMYK 21/22/59/0
RGB 205/187/127

CMYK 5/6/28/0
RGB 242/231/191

CMYK 6/34/38/0
RGB 236/178/151

CMYK 0/9/8/0
RGB 107/189/163

CMYK 20/4/34/0
RGB 207/220/180

CMYK 25/11/4/0
RGB 188/208/227

CMYK 5/6/28/0
RGB 242/231/191

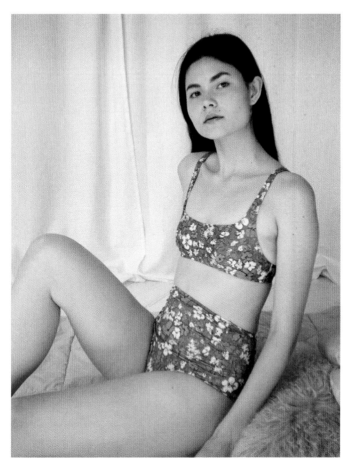

I Am That Shop

CMYK 7/3/47/0
RGB 239/233/158

CMYK 3/15/13/0
RGB 244/218/209

CMYK 50/27/13/0
RGB 132/165/194

CMYK 1/52/1/0
RGB 242/150/189

CMYK 30/46/1/0
RGB 180/145/193

CMYK 7/3/47/0
RGB 239/233/158

CMYK 17/4/49/0
RGB 214/220/153

CMYK 4/3/54/0
RGB 248/234/144

CMYK 0/18/13/0
RGB 252/215/207

CMYK 21/20/5/0
RGB 199/195/215

CMYK 10/15/4/0
RGB 226/213/223

CMYK 3/3/6/0
RGB 244/240/234

CMYK 22/5/15/0
RGB 197/218/214

CMYK 15/22/13/0
RGB 214/195/201

CMYK 3/3/6/0
RGB 244/240/234

CMYK 3/3/6/0
RGB 244/240/234

CMYK 12/7/2/0
RGB 226/213/223

CMYK 4/14/1/0
RGB 220/226/237

CMYK 17/4/49/0
RGB 214/220/153

CMYK 3/3/6/0
RGB 244/240/234

CMYK 4/14/1/0
RGB 239/220/232

CMYK 0/18/13/0
RGB 252/215/207

CMYK 3/3/6/0
RGB 244/240/234

CMYK 17/4/49/0
RGB 214/220/153

CMYK 21/20/5/0
RGB 199/195/215

CMYK 12/7/2/0
RGB 220/226/237

CMYK 10/15/4/0
RGB 226/213/223

CMYK 3/3/6/0
RGB 244/240/234

CMYK 4/14/1/0
RGB 239/220/232

CMYK 3/3/6/0
RGB 244/240/234

CMYK 4/3/54/0
RGB 248/234/144

CMYK 22/5/15/0
RGB 197/218/214

CMYK 21/20/5/0
RGB 199/195/215

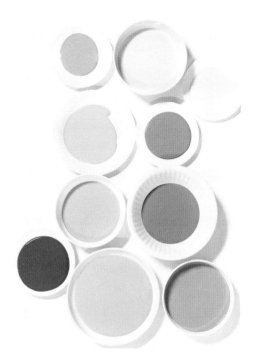

Dulux Colour

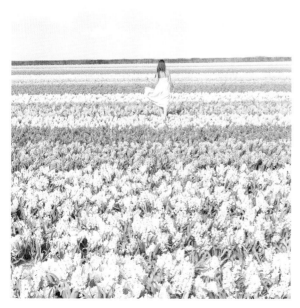

Marioly Vazquez

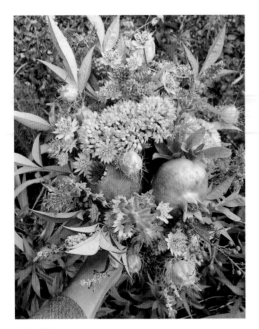

Olivia Thébaut

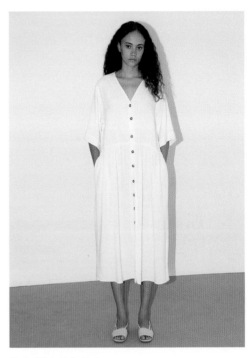

Diarte / Photo: Javier Morán

CMYK 27/36/0/0
RGB 184/163/221

CMYK 7/1/20/0
RGB 238/240/210

CMYK 20/3/22/0
RGB 203/223/203

CMYK 22/21/55/0
RGB 203/189/134

CMYK 1/18/8/0
RGB 248/215/215

CMYK 16/22/0/0
RGB 209/195/227

CMYK 13/7/49/0
RGB 226/220/151

CMYK 45/25/39/1
RGB 148/167/156

CMYK 1/4/20/0
RGB 252/239/207

CMYK 11/4/8/0
RGB 225/233/231

CMYK 23/31/0/0
RGB 192/173/216

CMYK 4/1/11/0
RGB 244/245/228

CMYK 1/4/20/0
RGB 252/239/207

CMYK 20/2/22/0
RGB 205/225/204

CMYK 32/18/58/0
RGB 180/186/131

CMYK 38/21/35/0
RGB 162/178/166

CMYK 7/2/31/0
RGB 239/236/189

CMYK 20/3/22/0
RGB 203/223/203

CMYK 1/7/8/0
RGB 249/235/228

CMYK 2/11/11/0
RGB 247/227/218

CMYK 1/32/42/0
RGB 247/184/146

CMYK 12/17/0/0
RGB 219/208/233

CMYK 27/36/0/0
RGB 184/163/221

CMYK 7/1/20/0
RGB 238/240/210

CMYK 20/3/22/0
RGB 203/223/203

CMYK 1/22/38/0
RGB 248/203/165

CMYK 21/31/26/0
RGB 201/173/171

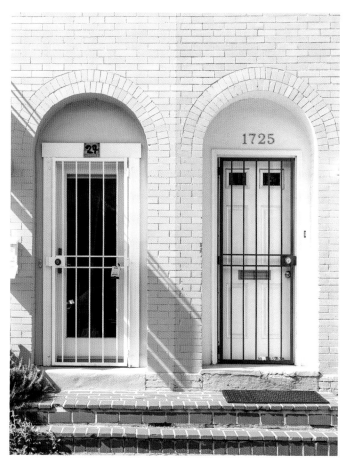

Erol Ahmed

CMYK 1/11/10/0
RGB 251/228/220

CMYK 23/2/9/0
RGB 194/224/227

CMYK 32/5/6/0
RGB 168/212/229

CMYK 32/5/6/0
RGB 168/212/229

CMYK 1/11/10/0
RGB 251/228/220

CMYK 5/2/2/0
RGB 239/243/244

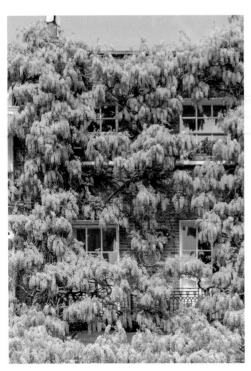

Marioly Vazquez

"**Spring** adds a
new **beauty** to all
that is."
-Jessica Harrelson

María del Río

CMYK 5/9/0/0
RGB 237/230/242

CMYK 18/25/0/0
RGB 205/190/233

CMYK 22/13/0/0
RGB 192/208/243

CMYK 2/15/0/0
RGB 244/220/238

CMYK 3/2/2/0
RGB 243/243/245

CMYK 14/9/44/0
RGB 221/215/160

CMYK 2/15/0/0
RGB 244/220/238

CMYK 3/2/2/0
RGB 243/243/245

CMYK 13/27/9/0
RGB 217/188/203

CMYK 3/2/2/0
RGB 253/233/226

CMYK 14/9/44/0
RGB 221/215/160

CMYK 2/15/0/0
RGB 244/220/238

CMYK 18/25/0/0
RGB 205/190/233

CMYK 3/2/2/0
RGB 243/243/245

CMYK 2/15/0/0
RGB 244/220/238

CMYK 18/25/0/0
RGB 205/190/233

CMYK 5/9/0/0
RGB 237/230/242

CMYK 22/13/0/0
RGB 192/208/243

CMYK 3/2/2/0
RGB 243/243/245

CMYK 2/15/0/0
RGB 244/220/238

CMYK 16/40/38/0
RGB 211/160/146

CMYK 3/2/2/0
RGB 243/243/245

CMYK 18/25/0/0
RGB 205/190/233

CMYK 3/2/2/0
RGB 243/243/245

CMYK 22/13/0/0
RGB 192/208/243

CMYK 14/9/44/0
RGB 221/215/160

CMYK 13/27/9/0
RGB 217/188/203

CMYK 0/16/3/0
RGB 253/220/227

CMYK 9/38/32/0
RGB 227/168/156

CMYK 25/17/33/0
RGB 193/195/173

CMYK 0/6/7/0
RGB 255/238/229

CMYK 7/4/42/0
RGB 239/230/167

CMYK 6/30/51/0
RGB 237/183/134

CMYK 7/4/42/0
RGB 239/230/167

CMYK 25/17/33/0
RGB 193/195/173

CMYK 0/6/7/0
RGB 255/238/229

CMYK 0/16/3/0
RGB 253/220/227

CMYK 35/19/27/0
RGB 169/185/181

CMYK 19/43/49/0
RGB 206/153/128

CMYK 0/6/7/0
RGB 255/238/229

CMYK 0/20/4/0
RGB 253/211/219

CMYK 0/34/50/0
RGB 255/181/132

CMYK 35/19/27/0
RGB 169/185/181

CMYK 19/43/49/0
RGB 206/153/128

CMYK 0/4/4/0
RGB 252/243/238

CMYK 0/20/4/0
RGB 253/211/219

CMYK 0/20/4/0
RGB 253/211/219

CMYK 0/34/50/0
RGB 255/181/132

CMYK 0/4/4/0
RGB 252/243/238

CMYK 7/4/42/0
RGB 239/230/167

CMYK 7/4/42/0
RGB 239/230/167

CMYK 0/4/4/0
RGB 252/243/238

CMYK 25/17/33/0
RGB 193/195/173

CMYK 19/43/49/0
RGB 206/153/128

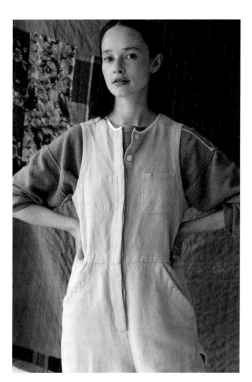

Caron Callahan / Photo: Josefina Santos

Marioly Vazquez

Leah Bartholomew

CMYK 9/20/2/0
RGB 227/203/221

CMYK 2/6/8/0
RGB 247/236/228

CMYK 12/2/32/0
RGB 226/231/187

CMYK 27/4/28/0
RGB 188/215/192

CMYK 3/2/4/0
RGB 244/243/241

CMYK 18/10/1/0
RGB 204/215/235

CMYK 3/2/4/0
RGB 244/243/241

CMYK 27/4/28/0
RGB 188/215/192

CMYK 18/10/1/0
RGB 204/215/235

CMYK 2/6/8/0
RGB 247/236/228

CMYK 9/32/2/0
RGB 225/182/208

CMYK 4/27/8/0
RGB 238/194/205

CMYK 3/2/4/0
RGB 244/243/241

CMYK 18/11/65/0
RGB 214/207/120

CMYK 27/4/28/0
RGB 188/215/192

CMYK 3/2/4/0
RGB 244/243/241

CMYK 22/20/62/0
RGB 204/190/122

CMYK 2/6/8/0
RGB 247/236/228

CMYK 37/30/65/2
RGB 167/160/111

CMYK 9/20/2/0
RGB 227/203/221

CMYK 2/6/8/0
RGB 247/236/228

CMYK 15/11/13//0
RGB 215/216/213

CMYK 12/2/32/0
RGB 226/231/187

CMYK 3/2/4/0
RGB 244/243/241

CMYK 27/4/28/0
RGB 188/215/192

CMYK 4/27/8/0
RGB 238/194/205

CMYK 9/32/2/0
RGB 225/182/208

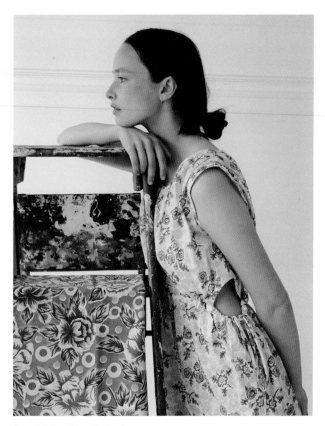

Caron Callahan / Photo: Josefina Santos

■ **CMYK** 21/48/29/0
RGB 201/145/154

□ **CMYK** 2/12/2/0
RGB 245/225/223

■ **CMYK** 18/12/7/0
RGB 204/210/220

□ **CMYK** 2/12/2/0
RGB 245/225/223

■ **CMYK** 5/57/49/0
RGB 232/135/119

■ **CMYK** 21/48/29/0
RGB 201/145/154

■ **CMYK** 5/57/49/0
RGB 232/135/119

■ **CMYK** 37/26/1/0
RGB 158/173/214

□ **CMYK** 2/12/2/0
RGB 245/225/223

S
P
R

I
N
G

NEUTRALS

Simple, soft, and sun-touched. These are the words that come to mind when I imagine spring neutrals. They are often warm-toned, and even the cooler spring neutrals will have a hint of yellow in the undertone. Some examples of these neutrals include a mix of ivory and creams, light olive, hazelnut, sand and peach. Keep your palette airy and natural, and if you include a deeper neutral, try balancing it out by pairing it with something a bit more delicate.

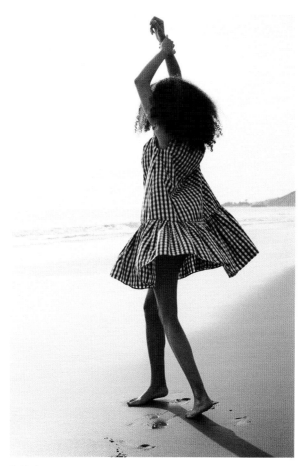

Sophia Aerts

CMYK 5/5/20/0
RGB 240/233/207

CMYK 21/22/49/0
RGB 205/188/142

CMYK 21/22/49/0
RGB 205/188/142

CMYK 4/12/14/0
RGB 242/222/211

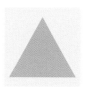

CMYK 8/11/20/0
RGB 233/220/200

CMYK 25/34/48/0
RGB 194/163/134

CMYK 26/39/21/0
RGB 191/158/172

CMYK 5/10/11/0
RGB 239/226/219

CMYK 5/5/9/0
RGB 240/236/227

CMYK 13/38/51/0
RGB 220/165/128

CMYK 9/15/34/0
RGB 230/210/173

CMYK 30/42/61/4
RGB 177/142/108

CMYK 7/15/15/0
RGB 234/215/206

CMYK 14/35/54/0
RGB 219/169/126

CMYK 29/43/68/6
RGB 176/135/95

CMYK 22/40/21/0
RGB 198/158/170

CMYK 5/5/9/0
RGB 240/236/227

CMYK 7/14/23/0
RGB 234/214/192

CMYK 5/5/9/0
RGB 240/236/227

CMYK 18/24/20/0
RGB 209/188/187

CMYK 18/44/59/1
RGB 209/151/113

CMYK 5/5/9/0
RGB 240/236/227

CMYK 9/12/25/0
RGB 231/217/191

CMYK 26/64/74/10
RGB 175/105/75

CMYK 14/28/42/0
RGB 218/183/149

CMYK 3/13/11/0
RGB 244/223/217

CMYK 36/52/58/11
RGB 157/118/101

CMYK 14/35/54/0
RGB 219/169/126

CMYK 5/7/11/0
RGB 239/232/223

CMYK 7/14/23/0
RGB 234/214/192

CMYK 4/6/19/0
RGB 245/233/207

CMYK 13/38/51/0
RGB 220/165/128

CMYK 3/13/11/0
RGB 244/223/217

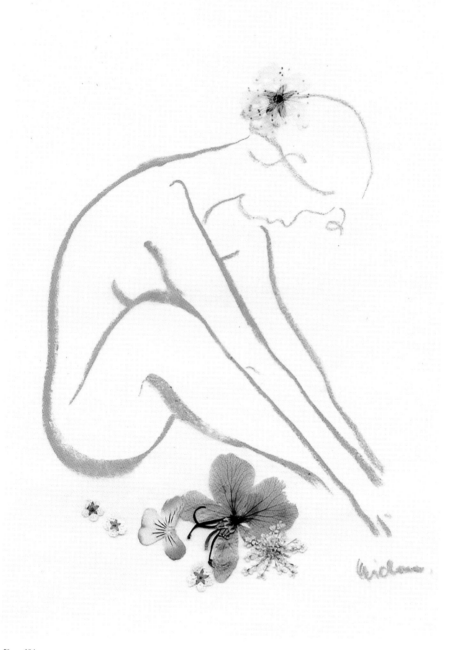

Zhang Yidan

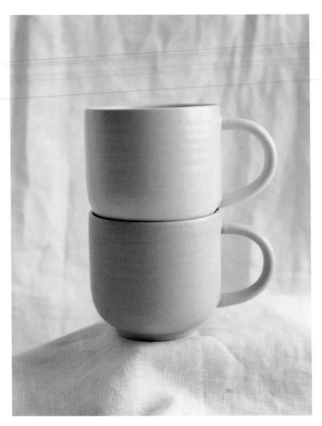

Hawkins New York at Shop BellJar

■ **CMYK** 30/29/45/0
RGB 182/170/144

■ **CMYK** 5/16/20/0
RGB 239/213/196

■ **CMYK** 6/7/12/0
RGB 237/231/219

■ **CMYK** 6/7/12/0
RGB 237/231/219

■ **CMYK** 14/11/14/0
RGB 216/215/211

■ **CMYK** 30/29/45/0
RGB 182/170/144

■ **CMYK** 15/28/42/0
RGB 217/183/149

■ **CMYK** 7/15/23/0
RGB 235/213/132

■ **CMYK** 6/7/12/0
RGB 237/231/219

CMYK 9/17/13/0
RGB 229/208/206

CMYK 16/29/61/0
RGB 215/178/118

CMYK 10/25/61/0
RGB 229/190/121

CMYK 1/4/6/0
RGB 250/241/234

CMYK 6/10/18/0
RGB 237/224/205

CMYK 24/32/71/1
RGB 196/165/101

CMYK 8/12/20/0
RGB 232/218/200

CMYK 47/62/66/35
RGB 106/79/68

CMYK 11/26/58/0
RGB 227/188/126

CMYK 4/4/9/0
RGB 243/239/228

CMYK 33/39/67/5
RGB 171/145/102

CMYK 6/11/12/0
RGB 237/223/215

CMYK 23/32/28/0
RGB 196/170/168

CMYK 4/4/9/0
RGB 243/239/228

CMYK 43/60/64/26
RGB 123/90/78

CMYK 10/21/39/0
RGB 229/199/160

CMYK 6/11/12/0
RGB 237/223/215

CMYK 43/60/64/26
RGB 123/90/78

CMYK 24/32/71/1
RGB 196/165/101

CMYK 8/12/20/0
RGB 232/218/200

CMYK 4/4/9/0
RGB 243/239/228

CMYK 23/32/28/0
RGB 196/170/168

CMYK 6/11/12/0
RGB 237/223/215

CMYK 10/25/61/0
RGB 229/190/121

CMYK 33/39/67/5
RGB 171/145/102

CMYK 4/4/9/0
RGB 243/239/228

CMYK 18/20/35/0
RGB 210/195/167

Ralfs Blumbergs

Amy Robinson

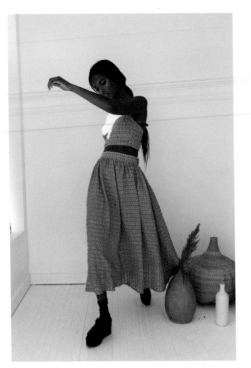

Caron Callahan Spring 2021 / Photo: Josefina Santos

*Spring neutrals will have a hint of yellow **undertone**.*

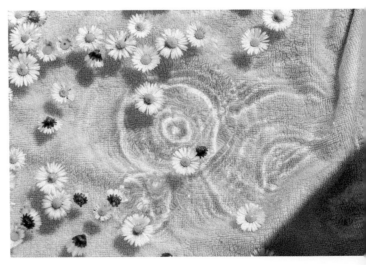

Camille Brodard

CMYK 7/5/9/0
RGB 235/233/226

CMYK 22/24/30/0
RGB 199/185/172

CMYK 27/20/24/0
RGB 188/186/185

CMYK 51/49/80/29
RGB 109/98/62

CMYK 0/48/0/0
RGB 238/236/236

CMYK 16/26/66/0
RGB 216/183/111

CMYK 7/8/8/0
RGB 234/228/226

CMYK 51/49/80/29
RGB 109/98/62

CMYK 16/33/74/0
RGB 216/170/93

CMYK 22/24/30/0
RGB 199/185/172

CMYK 9/7/8/0
RGB 229/228/227

CMYK 50/56/61/26
RGB 112/93/83

CMYK 22/17/20/0
RGB 199/198/194

CMYK 27/57/78/10
RGB 174/115/73

CMYK 56/61/56/32
RGB 96/80/80

CMYK 27/20/24/0
RGB 188/186/185

CMYK 56/61/56/32
RGB 96/80/80

CMYK 7/8/8/0
RGB 234/228/226

CMYK 27/57/78/10
RGB 174/115/73

CMYK 0/9/8/0
RGB 253/233/226

CMYK 21/17/18/0
RGB 200/199/198

CMYK 22/24/30/0
RGB 199/185/172

CMYK 27/57/78/10
RGB 174/115/73

CMYK 7/8/8/0
RGB 234/228/226

CMYK 51/49/80/29
RGB 109/98/62

CMYK 27/20/24/0
RGB 188/186/185

CMYK 16/33/74/0
RGB 216/170/93

CMYK 32/36/39/0
RGB 178/158/148

CMYK 10/9/9/0
RGB 226/223/222

CMYK 16/9/11/0
RGB 212/218/217

CMYK 35/15/27/0
RGB 169/192/184

CMYK 4/14/14/0
RGB 240/218/209

CMYK 32/36/39/0
RGB 178/158/148

CMYK 7/23/28/0
RGB 233/198/176

CMYK 4/4/9/0
RGB 243/239/228

CMYK 32/36/39/0
RGB 178/158/148

CMYK 10/9/9/0
RGB 226/223/222

CMYK 15/19/42/0
RGB 219/198/155

CMYK 4/4/9/0
RGB 243/239/228

CMYK 4/4/9/0
RGB 243/239/228

CMYK 35/15/27/0
RGB 169/192/184

CMYK 4/14/14/0
RGB 240/218/209

CMYK 4/4/9/0
RGB 243/239/228

CMYK 35/15/27/0
RGB 169/192/184

CMYK 15/19/42/0
RGB 219/198/155

CMYK 32/36/39/0
RGB 178/158/148

CMYK 4/14/14/0
RGB 240/218/209

CMYK 4/4/9/0
RGB 243/239/228

CMYK 18/19/25/0
RGB 209/198/185

CMYK 14//10/5/0
RGB 215/218/227

CMYK 4/4/9/0
RGB 243/239/228

CMYK 35/15/27/0
RGB 212/218/217

CMYK 32/36/39/0
RGB 178/158/148

CMYK 7/23/28/0
RGB 233/198/176

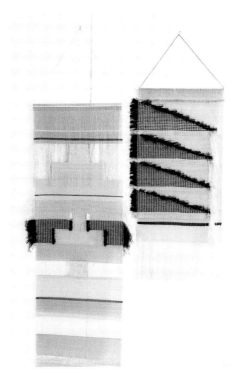

Justine Ashbee

Pair Up

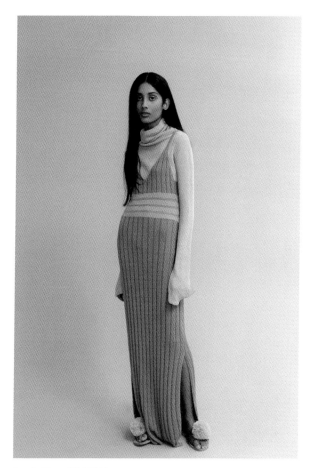

Samuji / Photo: Heli Blåfield

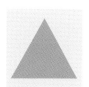

CMYK 22/35/55/0
RGB 201/163/124

CMYK 13/7/8/0
RGB 219/224/226

CMYK 7/14/29/0
RGB 234/213/183

CMYK 10/6/25/7
RGB 213/212/184

CMYK 13/25/65/0
RGB 224/188/114

CMYK 19/42/60/1
RGB 206/153/114

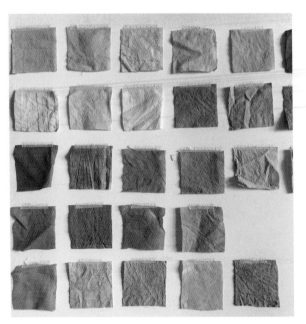

Joanna Fowles

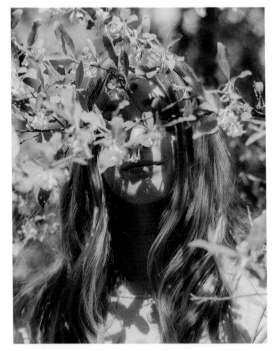

Nolan Perry

CMYK 9/24/31/0
RGB 230/194/170

CMYK 4/8/6/0
RGB 240/230/229

CMYK 3/11/14/0
RGB 243/225/212

CMYK 22/44/72/2
RGB 196/145/91

CMYK 31/29/29/0
RGB 178/170/168

CMYK 10/22/8/0
RGB 225/200/210

CMYK 14/14/37
RGB 220/208/168

CMYK 36/36/67/5
RGB 164/148/103

CMYK 6/8/16/0
RGB 237/228/212

CMYK 27/44/45/1
RGB 186/145/131

CMYK 10/13/47/0
RGB 230/211/150

CMYK 05/20/37/0
RGB 238/203/163

CMYK 5/9/10/0
RGB 238/228/222

CMYK 10/31/45/0
RGB 228/180/143

CMYK 19/50/69/2
RGB 203/137/93

CMYK 11/24/38/0
RGB 226/193/159

CMYK 25/32/22/0
RGB 192/170/177

CMYK 3/11/14/0
RGB 243/225/212

CMYK 22/44/72/2
RGB 196/145/91

CMYK 31/29/29/0
RGB 178/170/168

CMYK 36/33/69/4
RGB 167/154/103

CMYK 5/9/10/0
RGB 238/228/222

CMYK 19/22/51/0
RGB 209/189/139

CMYK 10/13/47/0
RGB 230/211/150

CMYK 9/24/31/0
RGB 203/137/93

CMYK 9/24/31/0
RGB 230/194/170

CMYK 26/52/83/8
RGB 180/125/68

■ CMYK 14/7/3/0
RGB 215/223/234

■ CMYK 78/71/53/54
RGB 45/47/59

■ CMYK 47/30/37/1
RGB 143/158/155

■ CMYK 8/13/26/0
RGB 233/216/188

■ CMYK 10/8/9/0
RGB 226/225/223

■ CMYK 28/16/19/0
RGB 185/195/196

■ CMYK 56/40/42/6
RGB 121/133/134

■ CMYK 10/8/9/0
RGB 226/225/223

■ CMYK 28/16/19/0
RGB 185/195/196

■ CMYK 10/8/9/0
RGB 226/225/223

■ CMYK 74/67/55/33
RGB 69/70/87

■ CMYK 22/15/15/0
RGB 197/202/205

■ CMYK 3/4/13/0
RGB 246/239/220

■ CMYK 16/21/35/0
RGB 214/194/167

■ CMYK 28/33/51/1
RGB 186/163/132

■ CMYK 10/8/9/0
RGB 226/225/223

■ CMYK 78/71/53/54
RGB 45/47/59

■ CMYK 16/21/35/0
RGB 214/194/167

■ CMYK 4/9/15/0
RGB 242/228/212

■ CMYK 14/7/3/0
RGB 215/223/234

■ CMYK 47/30/37/1
RGB 143/158/155

■ CMYK 10/8/9/0
RGB 226/225/223

■ CMYK 28/16/19/0
RGB 185/195/196

■ CMYK 3/4/13/0
RGB 246/239/220

■ CMYK 14/19/34/0
RGB 219/200/170

■ CMYK 28/16/19/0
RGB 185/195/196

■ CMYK 74/67/55/33
RGB 69/70/87

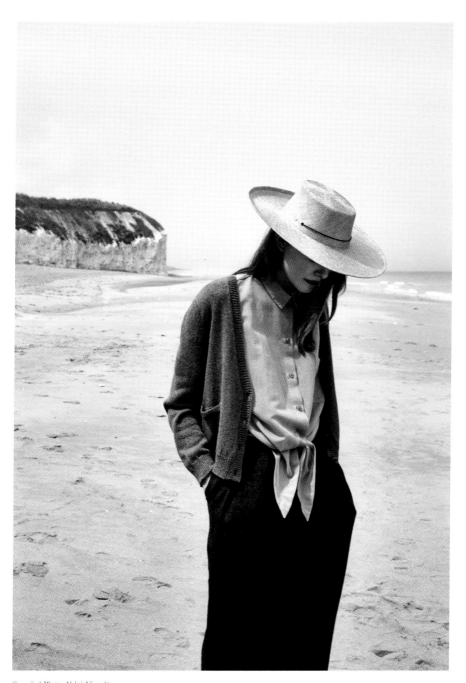

Samuji / Photo: Aleksi Niemelä

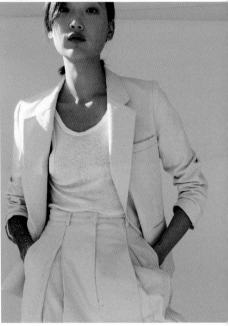

Goudzwaard Kees, "Tussenruimte" 2005, 80 x 60 cm, oil on canvas
Photo: Felix Tirry / Courtesy: Zeno X Gallery, Antwerp

Caron Callahan Spring 2021 / Photo: Josefina Santos

CMYK 13/8/7/0
RGB 219/223/227

CMYK 6/7/8/0
RGB 236/233/228

CMYK 17/28/45/0
RGB 213/180/134

CMYK 4/5/6/0
RGB 241/237/233

CMYK 21/13/20/0
RGB 197/205/198

CMYK 11/11/14/0
RGB 226/219/211

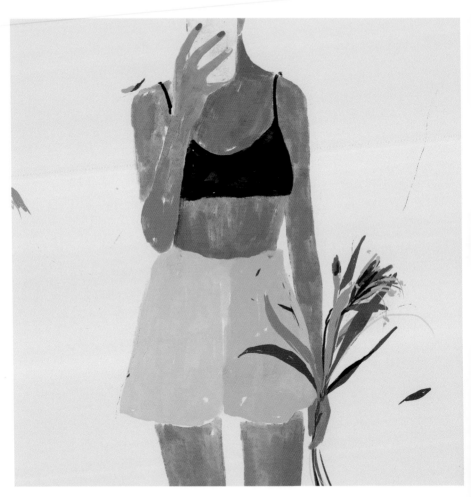

Anastasi Holubchyk by Moreartsdesign

CMYK 4/8/16/0
RGB 242/230/212

CMYK 17/18/43/0
RGB 214/198/155

CMYK 17/39/47/0
RGB 211/160/133

CMYK 5/19/21/0
RGB 239/208/192

CMYK 11/21/43/0
RGB 227/198/154

CMYK 4/8/16/0
RGB 242/230/212

CMYK 45/35/62/7
RGB 144/143/110

CMYK 6/22/45/0
RGB 237/198/148

CMYK 4/8/16/0
RGB 242/230/212

CMYK 4/8/16/0
RGB 242/230/212

CMYK 17/18/43/0
RGB 214/198/155

CMYK 11/21/43/0
RGB 227/198/154

CMYK 5/19/21/0
RGB 239/208/192

CMYK 4/8/16/0
RGB 242/230/212

CMYK 25/51/63/4
RGB 187/130/100

CMYK 4/8/16/0
RGB 242/230/212

CMYK 17/39/47/0
RGB 211/160/133

CMYK 11/21/43/0
RGB 227/198/154

CMYK 25/51/63/4
RGB 187/130/100

CMYK 17/18/43/0
RGB 214/198/155

CMYK 45/35/62/7
RGB 144/143/110

CMYK 6/22/45/0
RGB 237/198/148

CMYK 4/8/16/0
RGB 242/230/212

CMYK 25/51/63/4
RGB 187/130/100

CMYK 4/8/16/0
RGB 242/230/212

CMYK 17/39/47/0
RGB 211/160/133

CMYK 5/19/21/0
RGB 239/208/192

S

P

R

I

N

G

BOLDS

Spring bolds should represent a burst of cheer. It's no coincidence that bright yellow, a color that symbolizes happiness, would be a typical spring color, as the season itself indicates pleasance and cheerfulness. Honestly, you could probably throw out any color of the rainbow in this category—the point would be to just make a combination that makes you *feel* cheerful. As the season of spring is a time to reinvent and create newness, get creative here and find a combo that you find to be lively and bright!

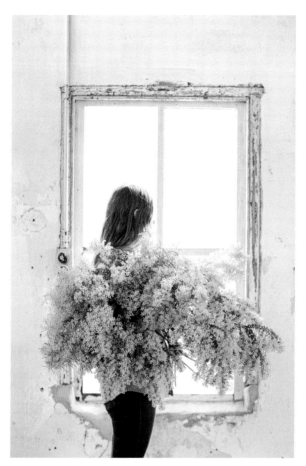

Luisa Brimble

CMYK 28/6/4/0
RGB 2178/213/232

CMYK 69/20/81/4
RGB 89/153/92

CMYK 4/2/78/0
RGB 250/233/90

CMYK 19/37/100/1
RGB 209/159/40

CMYK 69/20/81/4
RGB 89/153/92

CMYK 4/2/78/0
RGB 250/233/90

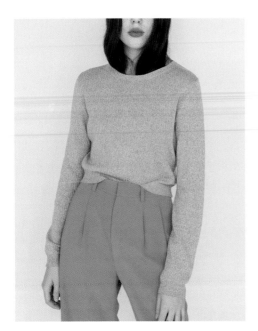

I Am That Shop

Elizabeth Olwen

CMYK 15/20/91/0
RGB 222/192/58

CMYK 0/15/10/0
RGB 251/222/216

CMYK 0/37/86/0
RGB 251/172/61

CMYK 51/4/42/0
RGB 126/192/165

CMYK 0/15/10/0
RGB 251/222/216

CMYK 2/56/24/0
RGB 238/140/152

CMYK 51/4/42/0
RGB 126/192/165

CMYK 0/32/10/0
RGB 247/187/196

CMYK 18/71/70/4
RGB 198/101/82

CMYK 6/5/10/0
RGB 238/234/225

CMYK 6/21/71/0
RGB 240/199/101

CMYK 0/37/86/0
RGB 251/172/61

CMYK 0/32/10/0
RGB 247/187/196

CMYK 51/4/42/0
RGB 126/192/165

CMYK 6/5/10/0
RGB 238/234/225

CMYK 0/37/86/0
RGB 251/172/61

CMYK 6/5/10/0
RGB 238/234/225

CMYK 15/20/91/0
RGB 222/192/58

CMYK 0/15/10/0
RGB 251/222/216

CMYK 0/15/10/0
RGB 251/222/216

CMYK 2/56/24/0
RGB 238/140/152

CMYK 51/4/42/0
RGB 126/192/165

CMYK 18/71/70/4
RGB 198/101/82

CMYK 15/20/91/0
RGB 222/192/58

CMYK 51/4/42/0
RGB 126/192/165

CMYK 6/5/10/0
RGB 238/234/225

CMYK 0/32/10/0
RGB 247/187/196

CMYK 78/27/71/10
RGB 56/133/101

CMYK 6/34/1/0
RGB 231/180/208

CMYK 3/70/88/0
RGB 235/110/56

CMYK 41/8/4/0
RGB 145/200/228

CMYK 22/42/2/0
RGB 195/155/196

CMYK 63/79/49/45
RGB 76/48/67

CMYK 0/25/23/0
RGB 249/200/183

CMYK 77/55/0/0
RGB 70/113/187

CMYK 22/42/2/0
RGB 195/155/196

CMYK 6/34/1/0
RGB 231/180/208

CMYK 3/4/6/0
RGB 244/239/233

CMYK 3/70/88/0
RGB 235/110/56

CMYK 3/26/92/0
RGB 247/190/49

CMYK 23/78/91/14
RGB 173/80/49

CMYK 41/8/4/0
RGB 145/200/228

CMYK 3/4/6/0
RGB 244/239/233

CMYK 41/8/4/0
RGB 145/200/228

CMYK 3/70/88/0
RGB 235/110/56

CMYK 78/27/71/10
RGB 56/133/101

CMYK 23/78/91/14
RGB 173/80/49

CMYK 3/26/92/0
RGB 247/190/49

CMYK 77/55/0/0
RGB 70/113/187

CMYK 3/4/6/0
RGB 244/239/233

CMYK 22/42/2/0
RGB 195/155/196

CMYK 63/79/49/45
RGB 76/48/67

CMYK 3/4/6/0
RGB 244/239/233

CMYK 78/27/71/10
RGB 56/133/101

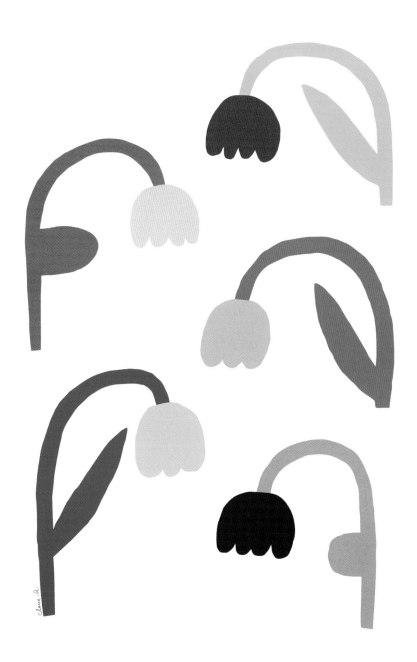

Claire Ritchie / "Rest Rest Rest Relax"

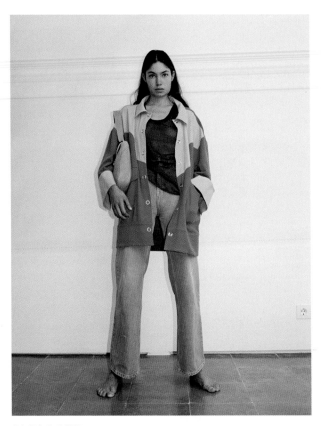

Gabriel for Sach SS21

CMYK 31/12/8/0
RGB 174/200/218

CMYK 0/21/2/0
RGB 250/210/223

CMYK 2/68/80/0
RGB 239/115/68

CMYK 2/68/80/0
RGB 239/115/68

CMYK 6/5/2/0
RGB 236/235/241

CMYK 0/21/2/0
RGB 250/210/223

CMYK 0/21/2/0
RGB 250/210/223

CMYK 2/68/80/0
RGB 239/115/68

CMYK 24/71/79/12
RGB 174/93/64

CMYK 76/18/11/0
RGB 3/162/202

CMYK 9/28/12/0
RGB 228/189/198

CMYK 0/34/64/0
RGB 254/180/108

CMYK 66/26/0/0
RGB 61/161/239

CMYK 63/53/9/0
RGB 110/120/173

CMYK 62/0/17/0
RGB 1/215/226

CMYK 14/37/9/0
RGB 213/165/189

CMYK 87/42/25/2
RGB 2/122/157

CMYK 62/5/16/0
RGB 83/188/228

CMYK 76/18/11/0
RGB 3/162/202

CMYK 89/58/14/1
RGB 30/105/160

CMYK 9/28/12/0
RGB 228/189/198

CMYK 2/47/52/0
RGB 240/154/121

CMYK 10/7/5/0
RGB 226/228/232

CMYK 62/0/17/0
RGB 1/215/226

CMYK 10/7/5/0
RGB 226/228/232

CMYK 76/18/11/0
RGB 3/162/202

CMYK 2/47/52/0
RGB 240/154/121

CMYK 87/42/25/2
RGB 2/122/157

CMYK 0/9/8/0
RGB 253/233/226

CMYK 89/58/14/1
RGB 30/105/160

CMYK 14/37/9/0
RGB 213/165/189

CMYK 17/4/11/0
RGB 208/225/223

CMYK 9/28/12/0
RGB 228/189/198

CMYK 2/47/52/0
RGB 240/154/121

CMYK 10/7/5/0
RGB 226/228/232

CMYK 0/34/64/0
RGB 254/180/108

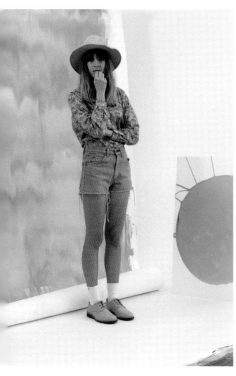

d Guys Don't Wear Leather / Photo: Estelle Hanania

Clark Van Der Beken

Model: Lily Yueng / Photo: Amy Yeung / Wardrobe: 4 Kinship

*"Spring is the time of year when it is summer in the **sun** and winter in the **shade**."*
-Charles Dickens

Ross Bruggink / Buddy-Buddy

CMYK 10/41/64/0
RGB 225/160/107

CMYK 28/55/0/0
RGB 182/130/187

CMYK 16/3/72/0
RGB 221/221/107

CMYK 52/18/28/0
RGB 128/175/179

CMYK 41/33/2/0
RGB 152/160/204

CMYK 12/7/7/0
RGB 221/225/228

CMYK 74/33/50/9
RGB 71/130/125

CMYK 41/33/2/0
RGB 152/160/204

CMYK 10/41/64/0
RGB 225/160/107

CMYK 23/49/10/0
RGB 195/143/178

CMYK 12/7/7/0
RGB 221/225/228

CMYK 69/36/25/0
RGB 88/139/165

CMYK 16/3/72/0
RGB 221/221/107

CMYK 10/41/64/0
RGB 225/160/107

CMYK 28/55/0/0
RGB 182/130/187

CMYK 16/3/72/0
RGB 221/221/107

CMYK 28/55/0/0
RGB 182/130/187

CMYK 10/41/64/0
RGB 225/160/107

CMYK 35/57/66/15
RGB 153/108/86

CMYK 52/18/28/0
RGB 128/175/179

CMYK 74/33/50/9
RGB 71/130/125

CMYK 12/7/7/0
RGB 221/225/228

CMYK 61/27/69/6
RGB 109/146/105

CMYK 41/33/2/0
RGB 152/160/204

CMYK 16/3/72/0
RGB 221/221/107

CMYK 28/55/0/0
RGB 182/130/187

CMYK 10/41/64/0
RGB 225/160/107

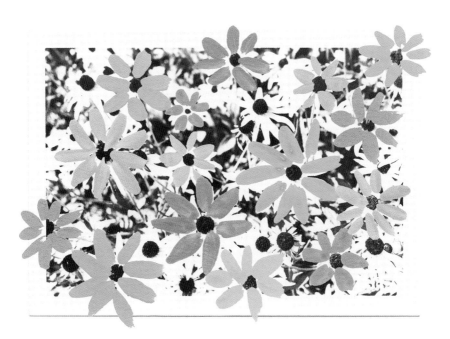

Jen Peters

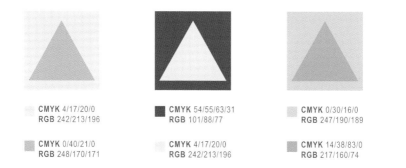

CMYK 4/17/20/0
RGB 242/213/196

CMYK 54/55/63/31
RGB 101/88/77

CMYK 0/30/16/0
RGB 247/190/189

CMYK 0/40/21/0
RGB 248/170/171

CMYK 4/17/20/0
RGB 242/213/196

CMYK 14/38/83/0
RGB 217/160/74

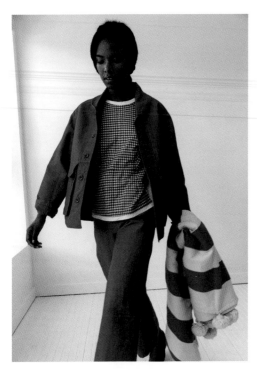

Caron Callahan / Photo: Josefina Santos

©VJ-Type ©Violaine&Jérémy

CMYK 80/52/21/2
RGB 65/113/155

CMYK 3/14/16/0
RGB 243/218/204

CMYK 24/46/24/0
RGB 196/148/162

CMYK 76/70/45/33
RGB 66/67/87

CMYK 10/8/18/0
RGB 229/225/208

CMYK 9/69/77/0
RGB 223/110/73

CMYK 42/30/89/5
RGB 155/153/71

CMYK 10/8/18/0
RGB 229/225/208

CMYK 24/46/24/0
RGB 196/148/162

CMYK 3/14/16/0
RGB 243/218/204

CMYK 33/21/10/0
RGB 169/183/205

CMYK 85/57/0/0
RGB 39/108/183

CMYK 85/57/0/0
RGB 39/108/183

CMYK 42/30/89/5
RGB 155/153/71

CMYK 10/8/18/0
RGB 229/225/208

CMYK 24/46/24/0
RGB 196/148/162

CMYK 3/14/16/0
RGB 243/218/204

CMYK 76/70/45/33
RGB 66/67/87

CMYK 33/21/10/0
RGB 169/183/205

CMYK 85/57/0/0
RGB 39/108/183

CMYK 100/85/23/8
RGB 1/62/127

CMYK 10/8/18/0
RGB 229/225/208

CMYK 9/69/77/0
RGB 223/110/73

CMYK 3/14/16/0
RGB 243/218/204

CMYK 42/30/89/5
RGB 155/153/71

CMYK 24/46/24/0
RGB 196/148/162

CMYK 100/78/11/1
RGB 6/78/150

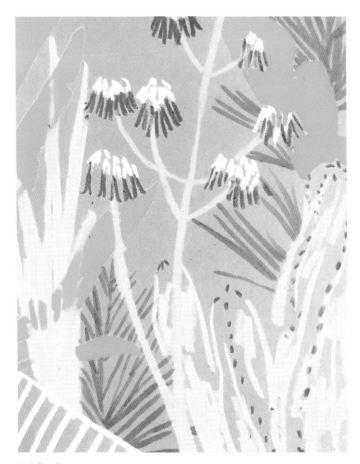

Annie Russell

CMYK 14/14/53/0
RGB 221/205/140

CMYK 9/73/0/0
RGB 235/100/188

CMYK 55/0/19/0
RGB 60/230/228

CMYK 4/14/4/0
RGB 239/219/226

CMYK 16/0/9/0
RGB 212/240/234

CMYK 44/27/80/4
RGB 150/156/86

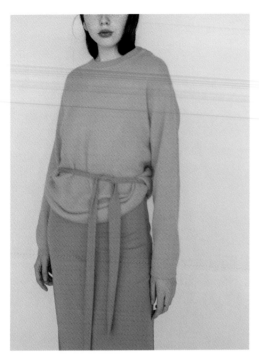

I Am That Shop

*"In nature **light** creates the color. In the picture **color** creates the light."*
-Hans Hoffman

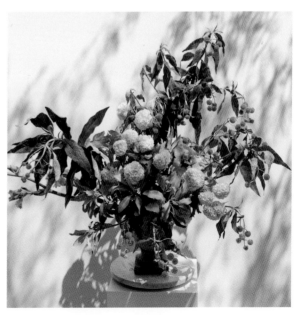

Stone Grove Florals

CMYK 0/38/87/0
RGB 252/170/58

CMYK 16/2/42/0
RGB 217/226/168

CMYK 24/16/0/0
RGB 188/200/232

CMYK 5/5/10/0
RGB 239/225/226

CMYK 62/15/88/1
RGB 112/167/84

CMYK 1/17/20/0
RGB 249/215/196

CMYK 5/0/33/0
RGB 244/245/187

CMYK 41/7/42/0
RGB 156/198/164

CMYK 75/26/100/11
RGB 75/134/40

CMYK 0/38/87/0
RGB 252/170/58

CMYK 62/15/88/1
RGB 112/167/84

CMYK 1/17/20/0
RGB 249/215/196

CMYK 5/0/12/0
RGB 241/245/226

CMYK 0/32/100/0
RGB 255/182/0

CMYK 0/49/82/0
RGB 250/150/67

CMYK 24/16/0/0
RGB 188/200/232

CMYK 19/39/100/1
RGB 209/155/19

CMYK 5/5/10/0
RGB 239/225/226

CMYK 0/49/82/0
RGB 250/150/67

CMYK 62/15/88/1
RGB 112/167/84

CMYK 5/0/12/0
RGB 241/245/226

CMYK 41/7/42/0
RGB 156/198/164

CMYK 1/17/20/0
RGB 249/215/196

CMYK 5/0/33/0
RGB 244/245/187

CMYK 19/39/100/1
RGB 209/155/19

CMYK 0/32/100/0
RGB 255/182/0

CMYK 0/49/82/0
RGB 250/150/67

CMYK 0/16/15/0
RGB 251/218/205

CMYK 4/58/95/0
RGB 237/132/45

CMYK 41/25/79/2
RGB 160/165/91

CMYK 6/28/0/0
RGB 249/190/249

CMYK 49/0/38/0
RGB 129/203/177

CMYK 21/10/94/0
RGB 209/205/58

CMYK 6/28/0/0
RGB 249/190/249

CMYK 17/4/0/0
RGB 206/228/248

CMYK 1/71/0/0
RGB 248/109/103

CMYK 4/58/95/0
RGB 237/132/45

CMYK 0/16/15/0
RGB 251/218/205

CMYK 6/28/0/0
RGB 249/190/249

CMYK 0/13/11/0
RGB 252/225/215

CMYK 0/44/83/0
RGB 255/160/63

CMYK 49/0/38/0
RGB 129/203/177

CMYK 49/0/38/0
RGB 129/203/177

CMYK 0/16/15/0
RGB 251/218/205

CMYK 41/25/79/2
RGB 160/165/91

CMYK 6/28/0/0
RGB 249/190/249

CMYK 0/13/11/0
RGB 252/225/215

CMYK 13/13/13/0
RGB 220/213/211

CMYK 4/33/0/0
RGB 237/184/212

CMYK 41/25/79/2
RGB 160/165/91

CMYK 0/46/47/0
RGB 251/158/127

CMYK 29/85/90/30
RGB 137/54/37

CMYK 1/71/0/0
RGB 248/109/103

CMYK 0/16/15/0
RGB 251/218/205

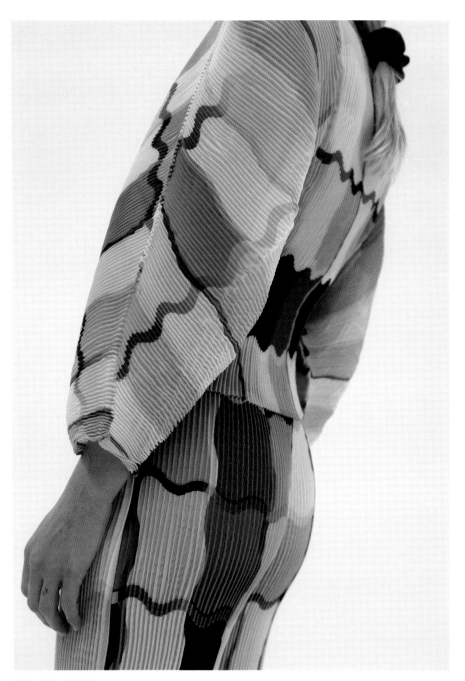

Beklina / Dress: Julia Heuer

Cecilie Karoline

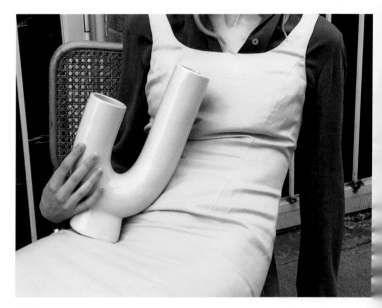

Ruhling

■ CMYK 0/48/65/0
RGB 251/153/98

CMYK 28/0/10/0
RGB 169/248/243

■ CMYK 87/54/46/24
RGB 35/88/102

CMYK 8/0/55/0
RGB 240/245/142

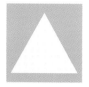

■ CMYK 33/23/74/1
RGB 177/173/100

CMYK 9/6/8/0
RGB 230/230/228

CMYK 9/6/8/0
RGB 230/230/228

CMYK 8/0/55/0
RGB 240/245/142

■ CMYK 0/48/65/0
RGB 251/153/98

CMYK 28/0/10/0
RGB 169/248/243

■ CMYK 87/54/46/24
RGB 35/88/102

■ CMYK 81/40/31/4
RGB 48/125/150

CMYK 8/0/55/0
RGB 240/245/142

■ CMYK 0/48/65/0
RGB 251/153/98

■ CMYK 87/54/46/24
RGB 35/88/102

■ CMYK 33/23/74/1
RGB 177/173/100

CMYK 8/0/55/0
RGB 240/245/142

■ CMYK 87/54/46/24
RGB 35/88/102

CMYK 9/6/8/0
RGB 230/230/228

CMYK 9/6/8/0
RGB 230/230/228

CMYK 34/0/19/0
RGB 152/217/213

CMYK 15/8/59/0
RGB 219/214/132

CMYK 8/0/55/0
RGB 240/245/142

■ CMYK 0/48/65/0
RGB 251/153/98

CMYK 28/0/10/0
RGB 169/248/243

CMYK 8/0/55/0
RGB 240/245/142

■ CMYK 87/54/46/24
RGB 35/88/102

ARTIST INDEX

page 27
Sophia Aerts

page 28
Sophia Aerts

page 28
Margaret Jeane

page 31
Rosie Harbottle

page 33
Muller Van Severen
Studio © Fien Muller

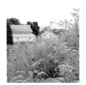

page 34
Cassidie Rahall
@therahallfarmhouse

page 34
Arianna Lago

page 37
I Am That Shop

page 37
Liana Jegers

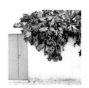

page 38
Hanna Sihvonen
(xo amys)

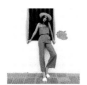

page 40
First Rite SS16
Model: Danica
Ferrin Klein
Photo: Maria del Río

page 40
Made by Jens

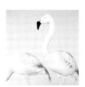

page 42
Sophia Aerts

page 42
Marissa Rodriguez

page 45
Oroboro Store

page 45
Saltstone Ceramics

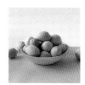

page 46
Bombabird Ceramics

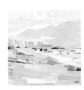

page 46
Margaret Jeane

page 49
G.Binsky
Photo: Leco Moura

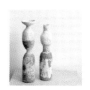

page 51
Yuko Nishikawa

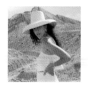

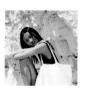

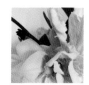

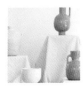
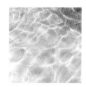
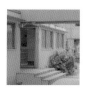

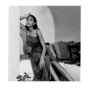

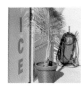

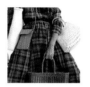

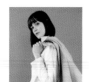

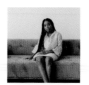

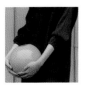

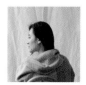

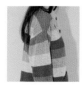

page 125
Ruby Bell Ceramics

page 126
Jasmine Dowling

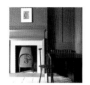

page 126
*The New Road Residence
by Blue Mountain School*

page 129
Joanna Fowles

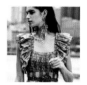

page 131
*Photo: Nina Westervelt
Ulla Johnson SS21*

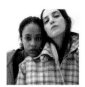

page 132
*Caron Callahan
Photo: Josefina Santos*

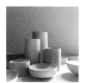

page 132
Luke Hope

page 135
*Stand and Earrings:
Beaufille
Photo: Sarah Blais*

page 135
*Clothing/Access: Beaufille
Photo: Sarah Blais
Styling: Monika Tatalovic
Model: Charlotte Carey
Hair/Makeup: Adam
Garland*

page 137
*Photo: Nina
Westervelt
Ulla Johnson FW20*

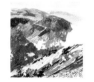

page 138
郭志宏*Chih-Hung KUO
"某山16 A Moun-
tain16"
150 x 150 cm
oil on canvas, 2015*

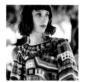

page 140
*Photo: Nina
Westervelt
Ulla Johnson SS21*

page 143
*Erica Tanov
Photo: Gabrielle Stiles*

page 143
*Georgie Home
@georgiehome*

page 144
*Marie Bernard
@marie_et_bernard*

page 144
*Erica Tanov
Photo: Terri Loewenthal*

page 146
Andrea Grützner

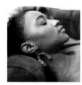

page 149
*Lawn Party
Styling: Julie Fuller
Photo: Alison Vagnini
Model: Taryn Vaughn*

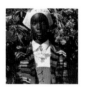

page 151
Arianna Lago

page 152
Annie Spratt

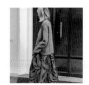

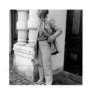
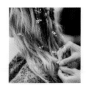
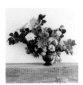

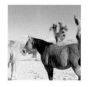

page 176
Sofie Sund

page 178
Rose Jocham
at Leif Shop

page 178
Sarita Jaccard for
Kamperett
Photo: María del Río

page 181
Sophia Aerts

page 183
Photo: Peyton Curry
Florals: Vessel & Stem
Styling/Design: Sabrina
Allison Design

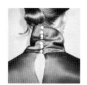

page 183
I Am That Shop

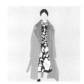

page 184
Megan Galante

page 186
Janneke Luursema

page 186
Taylr Anne Castro

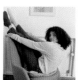

page 188
Arela
Photo: Emma
Sarpaniemi

page 188
Sandra Frey

page 191
Carla Cascales
Alimbau

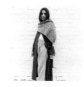

page 191
Botanical Inks
@botanicalinks
Photo: Kasia Kiliszek

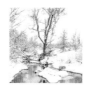

page 192
Jeffrey Hamilton

page 195
Bryony Gibbs

page 195
I Am That Shop

page 197
Mukuko Studio

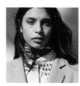

page 198
Freda Salvador
Model: Lilly Reilly
(Scout)
Photo: Maria del Río

page 198
Nani Williams

page 201
Rose Eads Design

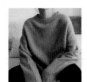
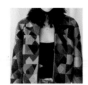

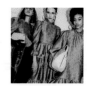
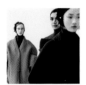
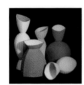
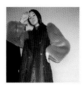

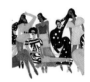

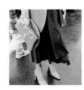

page 227
Beklina
Skirt: Julia Heuer

page 227
Mimi Ceramics

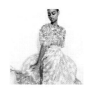

page 228
Photo: Nina Westervelt
Carolina Herrera SS20

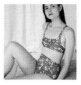

page 231
I Am That Shop

page 233
Dulux Colour

page 233
Marioly Vazquez

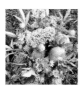

page 234
Olivia Thébaut

page 234
Diarte
Photo: Javier Morán

page 237
Erol Ahmed

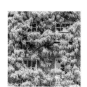

page 238
Marioly Vazquez

page 238
María del Río

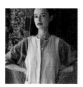

page 241
Caron Callahan
Photo: Josefina Santos

page 241
Marioly Vazquez

page 242
Leah Bartholomew

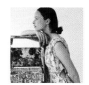

page 244
Caron Callahan
Photo: Josefina Santos

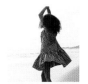

page 247
Sophia Aerts

page 249
Zhang Yidan
@yizdan

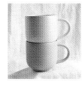

page 250
Hawkins New York
Shop BellJar

page 253
Ralfs Blumbergs

page 253
Amy Robinson

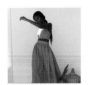

page 254
Caron Callahan
Spring 2021
Photo: Josefina Santos

page 254
Camille Brodard

page 257
Justine Ashbee

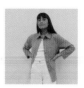

page 257
Pair Up

page 259
Samuji
Photo: Heli Blåfield

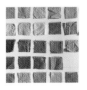

page 260
Joanna Fowles

page 260
Nolan Perry

page 263
Samuji
Photo: Aleksi Niemelä

page 264
Goudzwaard Kees
"Tussenruimte" 2005
80 x 60 cm, oil on canvas
Photo: Felix Tirry
Courtesy: Zeno X Gallery,
Antwerp

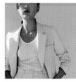

page 264
Caron Callahan
Photo: Josefina Santos

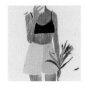

page 266
Anastasi Holubchyk
Moreartsdesign

page 269
Luisa Brimble

page 270
I Am That Shop

page 270
Elizabeth Olwen

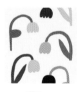

page 273
Claire Ritchie
"Rest Rest Rest Relax"

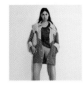

page 274
Gabriel for Sach SS21

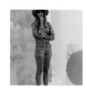

page 277
Good Guys Don't Wear
Leather
Photo: Estelle Hanania

page 277
Clark Van Der Beken

page 278
Model: Lily Yueng
Photo: Amy Yeung
Wardrobe: 4 Kinship

page 278
Ross Bruggink
Buddy-Buddy

page 281
Jen Peters

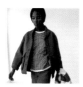

page 282
Caron Callahan
Photo: Josefina Santos

page 282
©VJ-Type
©Violaine&Jérémy

page 285
Annie Russell

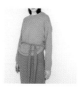

page 286
I Am That Shop

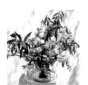

page 286
Stone Grove Florals
@_stonegrove

page 289
Beklina
Dress: Julia Heuer

page 290
Cecilie Karoline

page 290
Ruhling

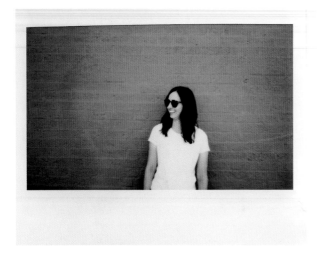

Lauren Wager is a designer, color consultant, and curator who is inspired by simple beauty. She is a partner in Georgie Home, a company that designs and produces home textile products. Lauren is the creator of the blog Color Collective, an online color resource for artists and designers. Her first book, *Palette Perfect*, evolved from her blog — pairing color palettes with the work of various designers, artists and photographers. She lives in Columbus, Ohio where she enjoys spending time with her family, collecting rocks, drinking coffee, and finding color combinations in unexpected places.